Santa Barbara Museum of Art
Selected Works

We would like to thank these major corporate sponsors
of the Santa Barbara Museum of Art's 50th Anniversary:

Nordstrom
Etablissements Casino/Smart & Final Stores
Santa Barbara Bank & Trust

Santa Barbara Museum of Art
Selected Works

Nancy Doll
Curator of Twentieth Century Art

Robert Henning, Jr.
Assistant Director for Curatorial Services

Susan Shin-tsu Tai
Curator of Asian Art

SANTA BARBARA MUSEUM OF ART

Published by the Santa Barbara Museum of Art
1130 State Street
Santa Barbara, California 93101

This catalogue was supported in part by a grant from the National
Endowment for the Arts, a federal agency.

Designer: John Balint
Typography: Balint-Reinecke, set in Goudy Old Style and Optima
Editor: Cathy Pollock
Printed in an edition of 4,000 in Hong Kong through Interprint.

**LIBRARY OF CONGRESS
CATALOGING-IN-PUBLICATION DATA**

Santa Barbara Museum of Art.
 Santa Barbara Museum of Art: selected works /
 Robert Henning, Jr. ... [et al.].
 p. cm.
 Includes bibliographical references.
 ISBN 0-89951-078-7 : $24.95. — ISBN 0-89951-077-9
 (pbk.) ; $9.95
Museum of Art—Catalogs. I. Henning, Robert. II. Title.
N742.S15A195 1991
708.194'91—dc20

PHOTOGRAPHY CREDITS

Santa Barbara Historical Society: p. 11, 12 (upper), 13 (upper)
Dave Folks: p. 13 (lower)
Wayne McCall: p. 14, 15, pl. 1, 3-91, 94-106, 108-110, 117,
 125-127, 131, 133-139
James Chen: front and back covers, pl. 2, 92, 93, 107, 111-116,
 118-124, 128-130, 132

Table of Contents

Dedication

This catalogue of the Museum's permanent collection is dedicated to Wright S. Ludington, a distinguished Museum patron and a man of remarkable vision and exemplary generosity.

A collector of strongly individual taste and perspicacity, Mr. Ludington launched several important Museum collection areas singlehandedly. The funerary loutrophoros—centerpiece of the entrance court and symbol to many of the Museum itself—was selected and placed there by him in 1941, a striking beginning to the present renowned collection of classical antiquities. By the end of the forties, he had donated significant works of British modernism by John Piper, Graham Sutherland, John Tunnard—artists little known in American museums until recently. His gifts have continued to create areas of excellence within the permanent collections: old master drawings, modern American art, Post-Impressionist art, and modern French drawings.

It is impossible to imagine the Santa Barbara Museum of Art without Wright S. Ludington's connoisseurship, involvement, and extraordinary generosity.

Introduction

FOR MANY YEARS, visitors to the Santa Barbara Museum of Art have been impressed with the quality, comprehensiveness, and diversity of its permanent collections. This publication is an opportunity to illustrate for a broad audience some of the Museum's extensive collection of over seventeen thousand works, and to explain how the collection has been formed over the past fifty years. It is a story of exemplary generosity, civic mindedness, and on-going stewardship that can be a source of great pride to everyone—past and present—who has been associated with the making of this Museum. The works of art which you see on view in the Museum and in this publication are part of a fascinating evolutionary process in which we are all participants.

The Santa Barbara Museum of Art's fiftieth anniversary not only marks an important milestone in the Museum's history but also comes at a time when staff and trustees are focusing close attention on the scope, purpose, and future directions of the permanent collection. We are recognizing that within this rich and diverse collection, key areas have formed, and that we need to concentrate future efforts on a careful collaborative process of refining, upgrading, and filling gaps in these areas.

The growth of our collection, like most, has been an organic process, subject as much to serendipitous factors as to any conscious efforts at planning. In 1941, the permanent collections already reflected a characteristic diversity and contained individually important works that we now recognize as harbingers of future strengths: American art; classical antiquities; local, regional, national, and international examples of what was then contemporary art and now recognized as aspects of modernism. Significantly, all of the works of art acquired in that first year were gifts, and even today gifts make up well over ninety percent of our collections. We have been extremely fortunate in having numerous benefactors who were knowledgeable and adventuresome collectors, and their tastes are clearly reflected in the galleries. Several areas of specialization established by these major donors have, by happy coincidence, been steadily enhanced by others. It is fortuitous, for example, that a number of collectors of early twentieth-century British art have found their way to Southern California and made the Santa Barbara Museum of Art the beneficiary of their pioneering collecting efforts. Donors, directors, trustees, and curatorial staff have all had a part in the dynamic process of creating a collection that is recognized today as exceptional for a museum of its size.

Interests and backgrounds of the Museum's first two directors played a special role in the initial shaping of the permanent collections. The influence of first director Donald Bear can be seen in the acquisitions of the forties, which included art of a strong "American character," art of a regionalist flavor, and works by many California-based younger artists. This initial base was expanded under second director Ala Story, whose broad international background and dynamic personality are clearly demonstrated in the European-influenced modernist acquisitions of the 1950s.

The interests and specialized knowledge of curators have also had a formative effect on the development of our collections, perhaps most notably in the way in which the Museum's photography collection had its start. (Not segregated in this publication as a separate section but rather integrated chronologically, the Museum's photography collection and its history are perhaps best discussed here.) A ground-breaking exhibition, *Attitudes, Photography in the 1970s* (May-August 1979), organized by former curator Fred Parker, established the collection through the acquisition of works by many of the featured artists, who were then emerging figures in the field of creative photography and are now of national importance. Pho-

tography holdings have since grown to over one thousand prints, representing the medium from the 1860s to the present, with emphasis on contemporary and modern work. The Arthur and Yolanda Steinman Collection, given in 1985, brought many classic images including works by Kertész, Manuel Bravo, and Cartier-Bresson. Other strengths of the Museum's collection include works by photographers with ties to Santa Barbara, such as Herbert Bayer, Marion Post Wolcott, and Ruth Thorne-Thomsen, as well as unusual vintage works by Edward Weston, Ilse Bing, and Imogen Cunningham. Special strengths include groups of prints by Harry Callahan and Max Yavno and a growing selection of portraiture by early French masters such as Carjat and Nadar.

In selecting works from the permanent collections to include in this publication, curators chose examples that represented important categories within the broad holdings of the Museum, keeping in mind the desire to create a visually interesting, compatible ensemble within each section. Space limitations dictated that many favorite or familiar examples be omitted, and, in some instances, a less familiar work by an artist rather than a more typical or oft-reproduced one was selected in order to give this publication special interest, variety, and impact. In addition, we made the difficult decision not to include certain sub-collections—among them Russian icons, African and pre-Columbian art, as well as our large collection of dolls and mechanical toys—in order to focus attention on those major collection areas which we have singled out for active future growth. Above all, our intent was to create an illustrated overview of the permanent collections that conveys something of its special nature and exceptional quality, and leaves readers eager to see more of this exceptional collection first hand.

Within the broad general categories, we have integrated works of various media—painting, sculpture, prints or other works on paper including photography—to combine historical or stylistic relationships, rather than make divisions according to the usual Museum departmental segregation of media. To suggest thematic connections, we selected some illustrations which suggest intentional or accidental links—similarity of subject matter or variations on certain motifs—that occur among different areas of the collection. Occasionally, we made comparative groupings, such as a preparatory study with a finished work of art, or a sampling of the unusual concentration of Ruskiniana that has come together coincidentally in our collection over time through gifts from different sources.

For the purposes of this publication, the collections have been divided into seven broad areas: Antiquities; European Pre-1800; European (chiefly England and France) 1800-1920; American; International Modernism; Contemporary; and Asian. (Not only does this division create manageable categories, but it also suggests the way in which the collections are usually exhibited in our galleries.) Each category is introduced with a brief description of its strengths and a history of its development. In our summaries of these main collection areas, we are often indebted to the work of various scholars and previous curators whose research and writings we have consulted or paraphrased.

Robert Henning, Jr.
Assistant Director for Curatorial Services

Nancy Doll
Curator of Twentieth Century Art

Susan Tai
Curator of Asian Art

A Brief History

THE HISTORY OF ANY museum is made up of many diverse elements: the collections it displays; the community which has helped to form and support it; the vision of trustees, directors, and staff who create its exhibitions, collections, and programs; and the architecture which provides it a setting and a home. Each of these factors has played a vital role in the development of the Santa Barbara Museum of Art, a privately supported, general art museum devoted to collecting and exhibiting in many areas of art history. The Museum is recognized as one of the finest of its size in the United States, and the fiftieth anniversary of its 1941 founding provides an appropriate occasion to take stock of its history and give recognition to the many individuals who have made it what it is today.

In the late 1930s, some of Santa Barbara's leading citizens, including internationally known artist Colin Campbell Cooper, Senator Thomas M. Storke (editor and publisher of the Santa Barbara News-Press), and art patrons Buell Hammett, Wright S. Ludington, and artists Lockwood de Forest and Dewitt Parshall, began a determined campaign to establish a community art museum. In 1940, Santa Barbara County supervisors agreed to purchase for use as an art museum the building at the corner of State and Anapamu Streets, which had been Santa Barbara's main post office from 1914 to 1932. With the Depression-era federal government selling buildings it no longer needed at half-price, the supervisors were able to buy the old post office for $48,730, and then

agreed to make it available rent- and tax-free. Several private individuals promised to serve as trustees and to take sole responsibility for maintenance, improvements, and operating expenses. Bolstered by their pledges of $50,000 toward renovation, and an annual budget of $25,000, the new Museum began to take shape.

The empty post office building had initially been chosen for its location and important physical amenities; steel construction and a large vault provided the safety and protection features needed to obtain art insurance. It lacked, however, an appropriate "museum look," so David Adler, an architect who was also a design consultant to the Art Institute of Chicago, was enlisted to create one. He simplified the building's existing Italianate facade and converted small postal work-rooms into galleries by covering the walls with specially-dyed fabrics and adding continuous lighting. Transforming the original post office lobby into a serene sculpture court was more difficult. He replaced the original rollback roof with a skylight, and the traditional post office writing stand with a mosaic-tiled

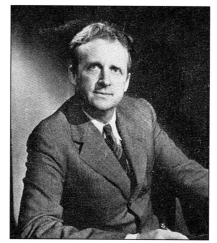
Buell Hammett, 1941.

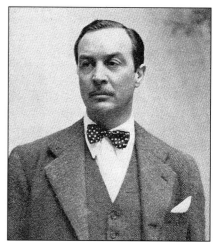
Wright S. Ludington, 1941.

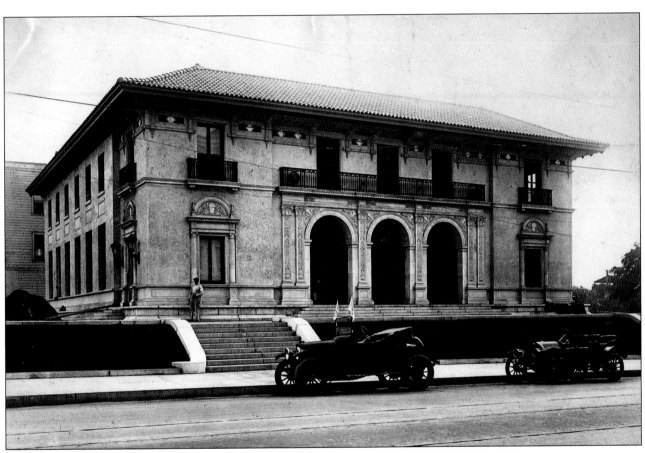

The old post office, as seen from State Street, circa 1914.

pond dominated by an imposing loutrophoros, an ancient Greek burial urn donated by Wright S. Ludington, whose generosity to the Museum has spanned four decades. The atrium is named in honor of Mr. Ludington's father, Charles Henry Ludington.

Early Museum patrons not only contributed funds for remodeling and building new galleries; they also donated generous gifts of art. Here again, Wright Ludington led the way with gifts of superb Greek and Roman antiquities and an important selection of watercolors and drawings. At the same time, the Muse-

um's fine collection of Oriental art got its start with gifts of Chinese, Japanese, and Indian art given by Mrs. Ina Campbell in memory of her husband, John.

In an auspicious beginning for the Museum's American art collection, founding president Buell Hammett acquired for the Museum the celebrated American primitive painting, *The Buffalo Hunter*. Nationally prominent art historian Donald Jeffries Bear, who, after an extensive nation-wide search was appointed the Museum's first director, had urged the purchase, telling Hammett, "If I had that picture, I

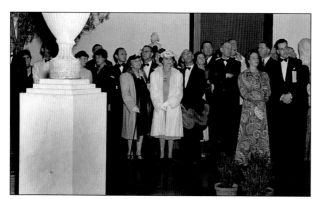

Inaugural reception, Ludington Court, June 5, 1941.

could form a great American collection around it."

He set the standard for that collection with the Museum's inaugural exhibition, *Painting Today and Yesterday in the United States*, and first on hand to see it were 1,500 students from La Cumbre and Santa Barbara Junior High Schools. Interestingly, the exact time of the opening was determined by astrology: Buell Hammett had the Museum's horoscope cast to determine the most auspicious hour, and at precisely 11:43 A.M. on June 5, 1941, the Museum opened its doors for the first time. Approximately 30,000 visitors viewed the exhibition, which also won the recognition of national art critics who were amazed that a city of 43,000 could mount such a major show.

Enthusiastic response to the fledgling Museum continued in its early years, to the point where expansion soon became necessary. To increase space, Katherine Dexter McCormick donated a major wing in her husband's memory. Designed by Santa Barbara architect Chester Carjola, the Stanley R. McCormick Gallery added 4,800 square feet of viewing space, and opened in January 1942 with a magnificent loan exhibition of nine-

teenth- and twentieth-century French paintings.

Despite the problems related to the advent of World War II (the Museum vault was used to store ammunition, much to Donald Bear's dismay), the Museum continued to flourish during its first decade. Landscaping was added to the front of the building in 1949, and there were important continuing additions to the collections. New programs and events were developed to serve a growing membership, and, in order to augment the five-person staff, the Junior League launched the first volunteer program. The Emma Wood Gallery, the Museum's first children's art education center, opened in 1942 as a result of Mrs. Adrian Wood's generosity, and education classes for both children and adults were started.

During the fifties, the Museum continued to grow. The Women's Board was formed in 1951, specifically to raise funds for the collections. In 1952, following the sudden death of Donald Bear, the trustees selected Ala Story, a native of Austria with twenty-three years of experience in the international world of art, as the next director. One of the first women to head an American

Donald J. Bear, 1941.

Ala Story, early 1950s

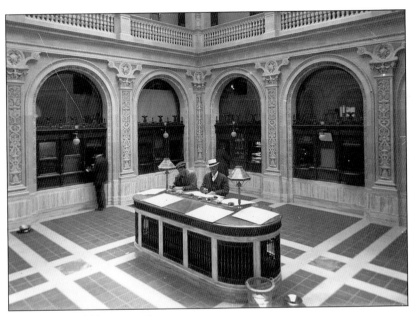

The old post office lobby, circa 1915.

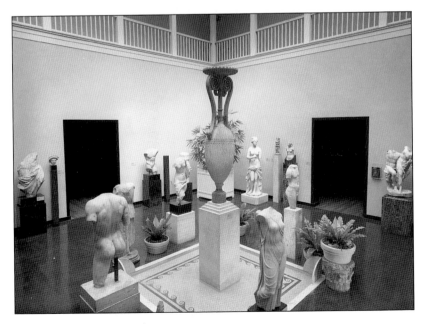

Ludington Court as it appears today.

museum, Ms. Story initiated in her five-year tenure a number of innovative exhibitions, including *The Rodin Sculptures*, the Pacific Coast Biennials, and one-man shows of Paul Klee and Grandma Moses.

Trustees and other friends of the Museum honored Mrs. Story on her resignation in 1957 by establishing the Ala Story Collection of International Modern Art. James W. Foster, Jr., former assistant director of the Baltimore Museum, was chosen as her successor and under his guidance, the Museum began to concentrate on building a significant American art collection. Mr. and Mrs. Sterling Morton created a fund to acquire American art, and with Foster's help and advice, Preston Morton purchased forty-six paintings to establish the now-celebrated Preston Morton Collection of American Art. To house that collection, the Mortons donated the Preston Morton Wing, as well as another gallery named for Sterling Morton, which together greatly increased exhibition space.

In addition to the Museum's physical expansion, the sixties saw the beginnings of the docent program (under the direction of the Junior League), a gift shop, and an art rental gallery. When James Foster left Santa Barbara in 1963, Museum trustees hired as director Thomas B. Leavitt, then head of the Pasadena Museum of Art. Leavitt organized the exhibition

Paul Mills, 1978.

which marked the Museum's twenty-fifth anniversary, and which bore witness to its involvement in contemporary art: *Directions in Kinetic Sculpture*. He also presided over new growth that saw Museum holdings reach 2,800 objects, membership grow to 1,250, and an Arts Auxiliary formed to provide much-needed new volunteer support.

During this period, too, Katherine Dexter McCormick left the Museum an important bequest. Included were a collection of French Impressionist paintings (among them three important works by Claude Monet), and her house. Since then, this residence at 1600 Santa Barbara Street has been the site of a variety of fundraising activities, and, as a part of the Museum's fiftieth anniversary celebration, is currently being transformed into a state-of-the-art Museum education center.

In 1970, Paul Mills, chief curator of art at the Oakland Museum, became director, and over the years, supervised the largest period of growth in the Museum's history. Programs and activities had increased in proportion to the collection, which now contained over 6,000 works of art. Notable gifts expanded and enriched the collections, particularly in the areas of Asian art, works by California artists, and contemporary ceramics. *Two Planes Vertical-Horizontal II* by George Rickey, which has now become the most visible symbol of the Museum to passers-by, was installed on the State Street terrace. An art library was established, scholarly catalogues of portions of the permanent collection as well as of temporary exhibitions were produced, lecture series and film series were expanded, and an active travel program inaugurated.

This increased activity encouraged the trustees to look ahead towards future growth. They first considered moving the Museum to El Mirasol (now the Alice Keck Park Memorial Garden), but this plan was abandoned when local merchants impressed upon trustees the importance to visitors of the downtown State Street location. Then, in 1977, the Museum received the largest unrestricted gift in its history, a bequest of oil stock from former trustee Alice Keck Park. This provided another solution, enabling the Museum to build a new wing and renovate the original building. In April 1982, ground was broken for the three-year project overseen by Santa Barbara architect Paul Gray. This expansion and renovation retained the original three-story structure while increasing Museum space by 67% and doubling exisiting gallery space. The 157-seat Mary Craig Auditorium was constructed on the ground floor and art storage vaults were located in the basement to house the growing collection. The 30,000 volume art library was renamed the Constance and George Fearing Library and equipped to serve as a major research facility for Museum staff and members of the public. The present arrangement of two entrances was established, and offices and a public elevator were added. An unseen but vitally important facet of this expansion was the installation of sophisticated climate controls to maintain constant temperature and humidity, special lighting and skylights to enhance the galleries, and security and fire systems. These improvements established the Museum as fully qualified and equipped

Richard West, 1988

to care for its collections and present major loan exhibitions according to the highest professional standards.

With plans for the Museum's future secure, Paul Mills retired from the institution he had led through such important changes. In 1983, the Museum welcomed director, Richard V. West, who had been director of the Crocker Art Museum in Sacramento. During his tenure, the Museum inaugurated its first major endowment campaign and the creation of The Santa Barbara Museum of Art Education Center at McCormick House. West resigned as director in 1990, having presided over the expansion of the collection through the acquisition of the Steinman Collection of photographs, the generous gift by Mr. and Mrs. Albert Broccoli and Mr. and Mrs. Michael Wilson of an extensive collection of early French lithographs, and the growth of both French and early twentieth-century British art collections.

On the occasion of the Museum's twenty-fifth anniversary, then-director Thomas Leavitt remarked, "In a very real sense, a community gets the art museum it deserves. The quality and size of its collections, the distinction of its exhibitions, and the rate of its growth usually reflect the degree of awareness and enthusiasm of local patrons." Today the Santa Barbara Museum of Art is a symbol of the vision, dedication, and generous support of a community which throughout its history has taken pride in the quality of life and cultural traditions which sustain it. For fifty years, individual generosity has added to the vision of the Museum's founders when they transformed an abandoned post office into an art museum for Santa Barbara.

The Museum receives no regular operating funds from city, county, state, or federal government, yet today its property and holdings are valued at over $75 million. More important, a rich variety of exhibitions, drawn from the Museum's permanent collections as well as from private collectors and institutions of national and international renown, allow over 150,000 visitors a year to explore the arts of the past and the present. Special programs, lectures, films, and educational activities provide audiences with an even deeper appreciation and understanding of the works on view.

In its half-century of existence the Museum has grown tremendously. All who are associated with it look forward to a richly rewarding future of collecting and exhibiting art of the highest quality and making it accessible to all.

Antiquities

AT THE ENTRANCE to the Museum and serving as an appropriate introduction to later periods of Western art, is the outstanding collection of antiquities founded and consisting almost entirely of donations from Wright S. Ludington. It is housed impressively in the skylit court named in honor of his father, Charles H. Ludington. Chief among these holdings are approximately twenty-five examples of Greco-Roman marble and stone sculpture, beginning chronologically with a Cypriot head of the sixth century B.C. and continuing to the third century A.D. with a vivid example of Roman bronze portraiture [pl. 5]. These gifts—which began with the placing of the Greek fourth century B.C. funerary loutrophoros, a vase-shaped grave ornament, at the center of Ludington Court for the Museum's opening in 1941—have continued to the present day and include the installation of the monumental *Lansdowne Hermes* on the occasion of the opening of the renovated Museum in 1985.

A regular succession of gifts from Mr. Ludington also significantly expanded the collection of smaller Greek pieces. In 1955, the Museum received a group of ceramic vessels decorated with painted red and black figures which includes most major forms and styles. The formal gift in 1981, after a long-term loan, of a superb selection of ancient bronzes traces their evolution from the Geometric Period through the full flowering of figurative representation of fourth and fifth centuries B.C., and culminates in a minor masterpiece, the small bronze *Dancing Girl* of approximately 200 B.C.

Throughout the 1970s, Ludington gifts continued to enhance this collection, while also expanding the Museum's holdings of ancient art into the earlier period of Egyptian relief carving and sculpture.

Several other donors have created an extensive collection of ancient glass which includes most major types of vessels produced by the ancient Mediterranean cultures beginning as early as the sixth century B.C. with examples of both luxury items and utilitarian forms. The collection traces the growing technology and sophistication of ancient craftsmen, from early core-wound processes to later examples of enameled and wheel-cut decoration. This historical sequence is paralleled in a large group of Greek ceramic and bronze objects given by Mr. and Mrs. Earnest C. Watson and ancient Near Eastern material donated by Mr. and Mrs. Lee O. Wolcott which includes works from numerous early cultures such as Amlash and Luristan.

In its present form, the antiquities collection illustrates the foundation of Western artistic traditions in sculpture, bronze, ceramics, and decorative objects of great beauty and historical importance, while giving visitors a rare opportunity to experience through a wide range of forms and evolving styles the artistic accomplishments of the cultures of Greece and Rome. Some of these Greco-Roman sculptures serve as the only surviving record of lost Greek originals, while others exemplify Roman interest in portraiture and architecture. This exceptionally fine collection, rare among American museums, is rivaled in the west only by that of the J. Paul Getty Museum.

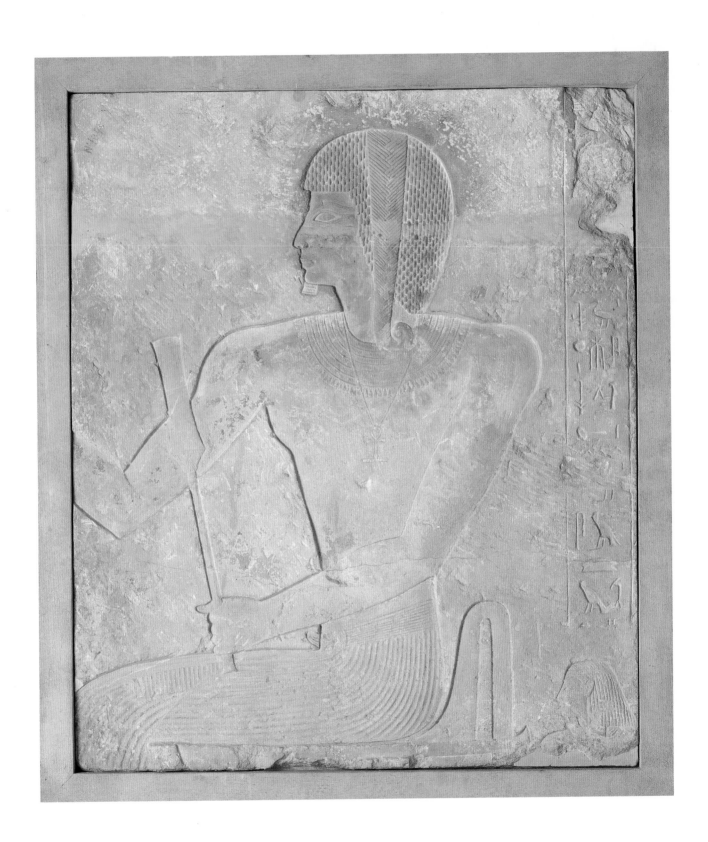

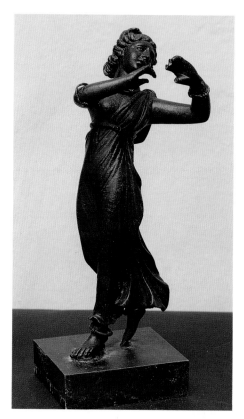

2. Asia Minor, ca. 200 B.C.
Dancing Girl
Bronze with silver necklace,
arm bands, and ankle bracelets
6.5 x 3" (16 x 7.5)
Gift of Wright S. Ludington

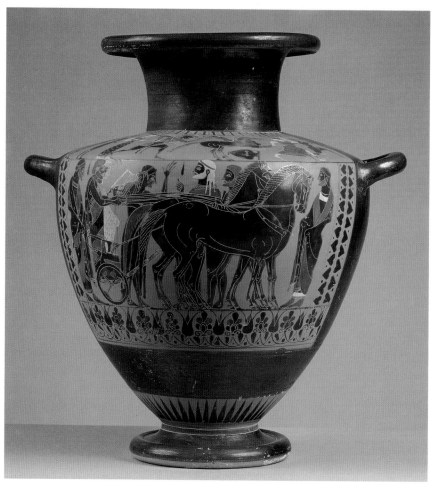

3. Greek, ca. 530 B.C.
(attributed to the Swing Painter)
Black-Figured Hydra
Ceramic
16 x 12 x 9.5" (40.5 x 30.5 x 24)
Gift of Wright S. Ludington

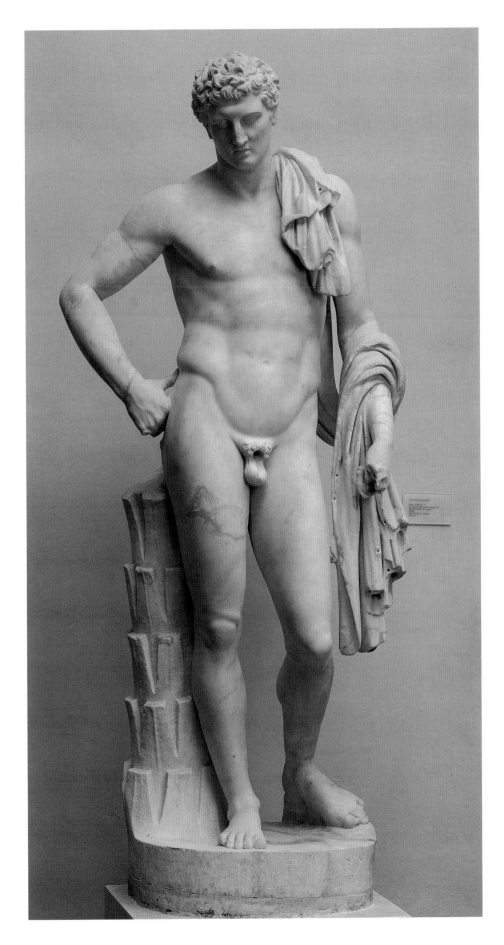

4. Roman, Hadrianic Period (117 – 138 B.C.)
Lansdowne Hermes
Marble
7'1" (216)
Gift of Wright S. Ludington

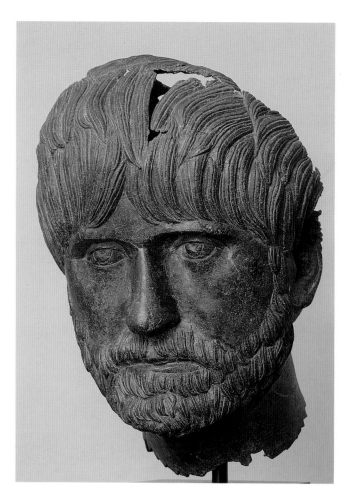

5. Roman, Gallienic, mid-third century A.D.
Bearded Head
Bronze
11.5" (29)
Gift of Wright S. Ludington

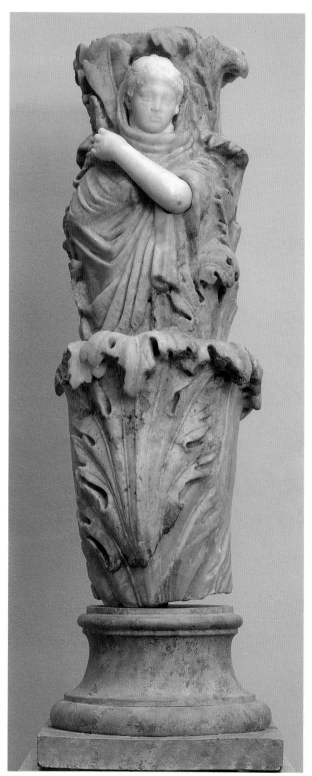

6. Roman, possibly early first century A.D.
Fragmentary Table Leg
Marble and alabaster
17.5" (44.5)
Gift of Wright S. Ludington

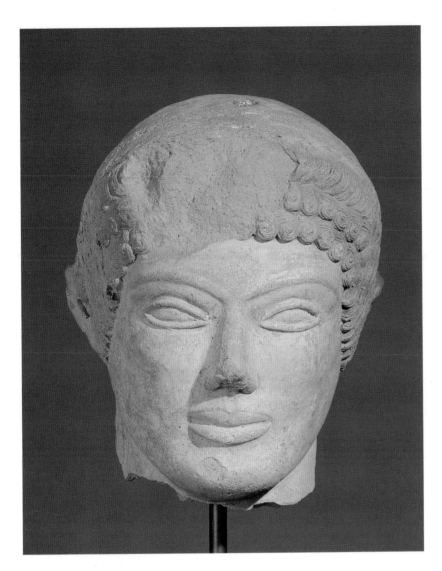

7. Sicilian, sixth century B.C.
Head of a Youth
Terracotta
7.5 x 6 x 5" (18.5 x 15 x 12)
Gift of Robert M. Light
in honor of Wright S. Ludington

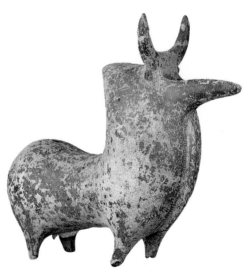

8. Persian, 1000 – 900 B.C.
Bull
Amlash ware, ceramic
9" (22)
Gift of Mr. and Mrs. Lee O. Wolcott

European Pre-1800

THE PRIMARY STRENGTH of earlier European art in the collection is a fine and growing assembly of drawings and prints which has been formed over time through a combination of donations and purchases. Started with a few individual gifts in the late 1940s, the old master drawing collection has grown to over six hundred works. These holdings represent western European national schools by a combination of lesser known masters and major artists with some emphasis on seventeenth- and eighteenth-century Italy, and a fine sequence of French works beginning with a Claude pastoral scene and important eighteenth century examples such as a Francois Boucher landscape, figure studies by Watteau and Lancret and an imaginary landscape with ruins by Hubert Robert. The latter works serve as a useful historical foundation to the Museum's rapidly expanding collection of nineteenth-century French art. In 1959, an exhibition of drawings for sale was the catalyst for the purchase and donation of some thirty works, and, since that time, Suzette Davidson, the Museum's Women's Board, collectors' trips, the Dicken Fund, and the Ide Fund have made possible continuing purchases of important drawings.

This collection of drawings, watercolors, and gouaches is considerably enhanced by a print collection of increasing importance. Begun in the fifties with individual gifts including works by Rembrandt [pl. 15] and artists of the Dutch school during the 1950s, this area now includes an important series by Piranesi, a complete collection of over thirty impressions of Canaletto etchings given by William A. Gumberts in 1979 [pl. 17], and key examples by the recognized masters of printmaking from Ugo da Carpi [pl. 11] and Dürer to Hogarth which trace the development of the graphic arts from the sixteenth through the eighteenth centuries.

A small group of paintings before 1800 contains individual works of interest but reflects no single area of strength or concentration, except for a small group of seventeenth-century Italian examples. These include a Caravaggio-influenced religious work by Giovanni Baglione [pl. 14], an extremely appealing and fully documented portrait of a young Italian of the late Medici court by Justus Sustermans, a monumental still life of musical instruments by Bartolomeo Bettera, and a large painting of *Hagar and Ismael visited by the Angel* attributed to Salvatore Rosa. A much earlier work in the collection, dating from the fifteenth century, is the superb and remarkably preserved altarpiece fragment by Lorenzo Monaco [pl. 12] acquired by purchase in 1967 as an unattributed work.

Northern European painting is represented by a number of characteristic works, among them a small panel of exceptional quality from the School of Hieronymous Bosch, *Christ Descending into Limbo*; a pair of sixteenth-century landscapes showing seasonal activities of July and August, by Isaac van Oosten; and a superb *Lamentation* which can be closely associated with the studio of Hans Memling. Among several examples of Spanish art is a rare and well-preserved fifteenth-century Aragonese *banco*, or tabernacle of painted wood.

9. Leonello Spada
Italian, 1576–1622
Saint Paul and the Viper
Pen and ink and wash
12 x 11.5" (30.5 x 28)
Museum purchase, Gift of Women's Board

10. Giovanni Battista Tiepolo
Italian, 1696–1770
Bearded Man in a Cloak
Pen and brown ink wash on paper
8 x 5.5" (20 x 14)
Gift of Wright S. Ludington

11. Ugo da Carpi
Italian, 1480–1532
Diogenes and the Cock
Chiaroscuro woodcut in four colors
19.5 x 14″ (49.5 x 35.5)
Museum purchase,
European Deaccessioning Funds

12. Lorenzo Monaco
Italian, 1370–1425
Martyrdom of Pope Caius, ca. 1394
Tempera and gold leaf on panel
17.5 x 23″ (44.5 x 58.5)
Museum purchase

13. Jacob Jordaens
Flemish, 1593–1678
The Entombment
Pen and brown ink wash
9 x 15" (22 x 37.5)
Gift of Donald Outerbridge

14. Giovanni Baglione
Italian, 1573–1644
*St. Catherine of Alexandria
Carried to Her Tomb by Angels*
Oil on canvas
49.5 x 65" (125.5 x 165)
Gift of Suzette and
Eugene Davidson

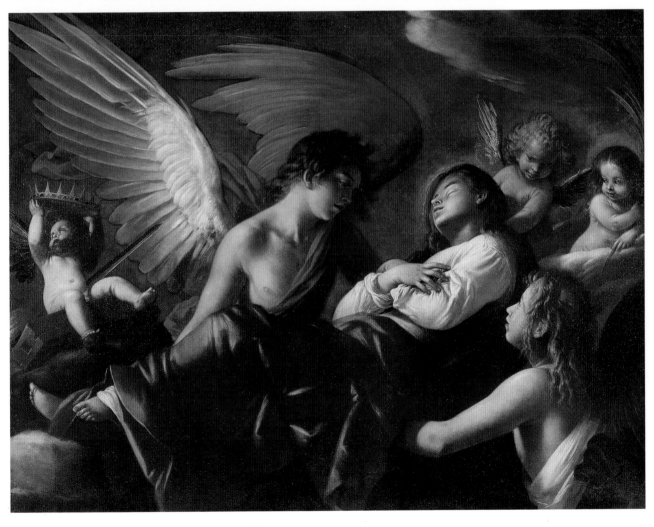

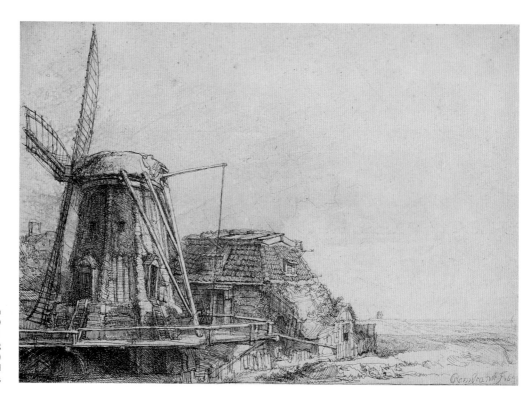

15. Rembrandt van Rijn
Flemish, 1606–1669
The Windmill, 1641
etching
6 x 8″ (15 x 20)
Gift of Carolyn C. Rowland
and Ruth C. Phillips

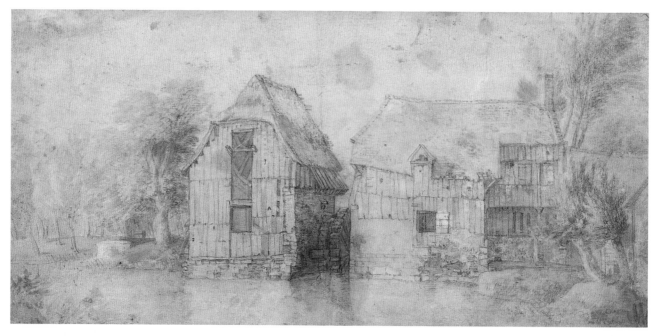

16. Unknown artist
Netherlandish, 17th century
A Mill by a Stream
Watercolor
6.5 x 13.5″ (16.5 x 34.5)
Museum purchase

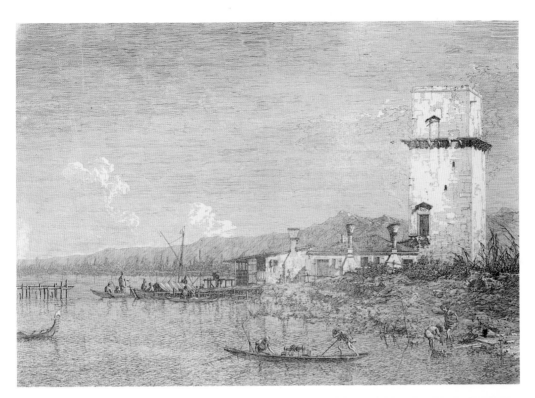

17. Antonio Canal (Canaletto)
Italian, 1697–1768
La Torre de Malghera
Etching
Image 12 x 17" (30.5 x 43)
Gift of William A. Gumberts
in honor of Robert M. Light

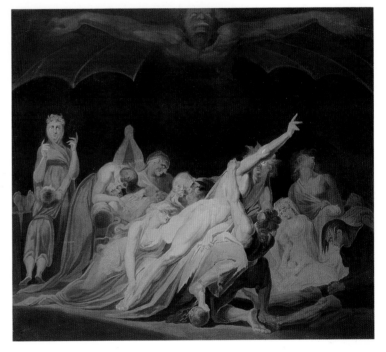

18. Paul Sandby
English, 1725–1809
View of a Rocky Pool with Windsor Castle, 1763
Black chalk over grey wash with some white
Plate/Image 20.5 x 16" (52 x 40.5)
Museum purchase, Deaccessioning Funds from gifts of
Dr. & Mrs. Isador Berman and Mr. & Mrs. David C. Marcus

19. Henry Fuseli
English, 1741–1825
Passing of the Angel of Death
Ink wash heightened with white
21 x 23.5" (53 x 59.5)
Museum purchase

European 1800–1920

BEGINNING WITH extraordinary gifts by Wright S. Ludington in 1941, the Museum's representation of French art is virtually a sequence of masterpieces, while other European nations or national schools are limited to a concentration of British artists—mainly reflected in drawings and prints—and an interesting miscellany from other countries.

Prints and drawings by Matisse, Derain, Picasso, and Degas signified an auspicious beginning to a collection that has become a main area of concentration. These early twentieth-century works by the outstanding masters of French draftsmanship form an important basis for our extensive holdings of later French modernism. The bequest of Katherine Dexter McCormick in 1968 established a cornerstone of French paintings that is now a major attraction for Museum visitors. Three paintings by Monet—two examples from his series of fog-shrouded London bridges, and his landscape of Bordighera—reveal differing and memorable aspects of this artist's work. The collection also includes an important masterpiece by Berthe Morisot, *View of Paris from the Trocadero*, good exemplars of Boudin, Daubigny, among others, and a growing selection of sculpture by nineteenth-century figures such as Carpeaux, Falguière, Carrier-Belleuse, and Rodin. A combination of purchases, bequests, and donations has steadily brought to the Museum works by Fantin-Latour, Rouault, Forain and others.

The French collection's most dramatic growth took place in 1985 with the gift of over four thousand nineteenth-century prints from Albert and Dana Broccoli and Mr. and Mrs. Michael Wilson, creating overnight an pivotal area of specialization of both scholarly and general interest. Within a short time, other donors initiated a series of complementary gifts to this print collection, and in order to enrich its holdings in this area, the Museum has made a commitment to regular purchases of related nineteenth-century French drawings and watercolors. In addition, a growing body of preparatory drawings, lithographic stones, and woodblocks provides a fascinating introduction to the working methods of French artist-printmakers.

Allied to the French holdings is an unusually rich array of nineteenth-and early twentieth-century British art—both drawings and paintings—beginning with the conservative tradition of John Ruskin, and based on the 1953 bequest of Mrs. Ina T. Campbell who acquired six drawings along with the related material from the artist's heir. Examples by expatriates working in England include Fuseli, John Singer Sargent, and Alphonse Legros, with tentative late nineteenth-century English modernist aspirations reflected in drawings by Augustus John and a superb group of paintings of Walter Sickert and Philip Wilson Steer, the latter established by donors Mary and Will Richeson. An interesting aspect of British printmaking exists in the in-depth holdings of English japonisme wood block artists of the thirties, William Allen Seaby, Elizabeth Keith, William Giles and others. As with the French collection, British art and its later development is continued in the Museum's extensive modernist holdings.

Recent gifts and purchases continue to enrich this collection's strengths in late nineteenth-century artists, while gradually creating a more complete representation of their predecessors. Important works by Jules Breton, Lhermitte, Lambinet, Cogniet, and Bellangé reveal aspects of the development of landscape, genre, and academic traditions more complete or varied than the usual museum representation consisting often of only the most familiar names.

20. Raoul Dufy
French, 1880–1953
Composition, 1926
Oil on canvas
55.5 x 59 .5" (141 x 151)
Museum purchase with funds from
the bequest of Mrs. Alfred B. Clark

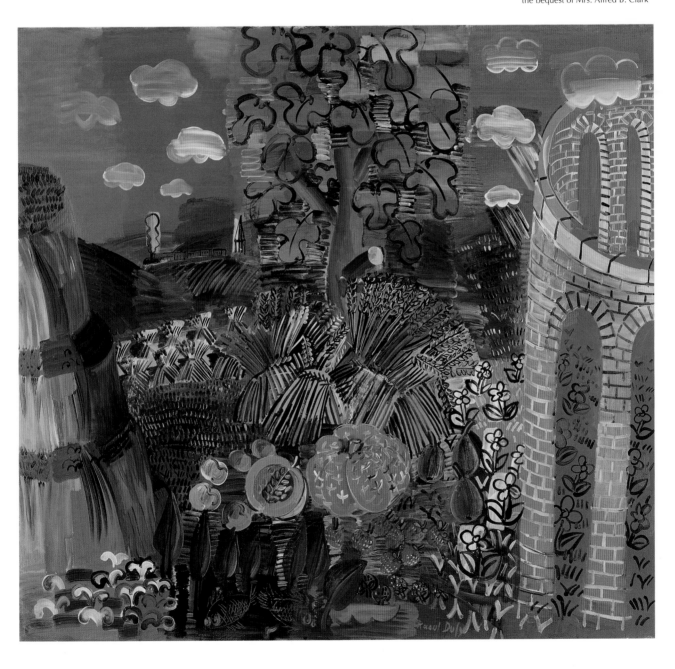

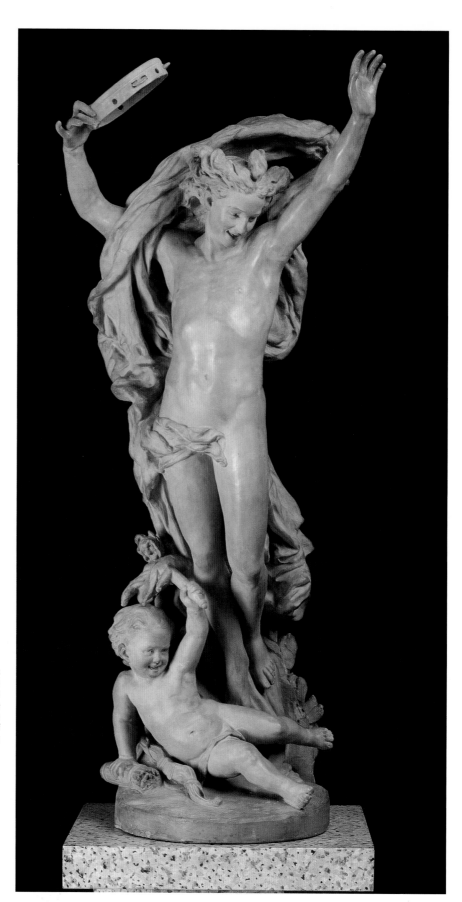

21. Jean-Baptiste Carpeaux
French, 1827-1875
Génie de la danse, 1875
Terracotta sculpture
40 x 18 x 30" (101.5 x 45.5 x 76)
Museum purchase, Deaccessioning Funds from gifts of
Joanne and Robert Kendall and Mrs. Courtney Hutton

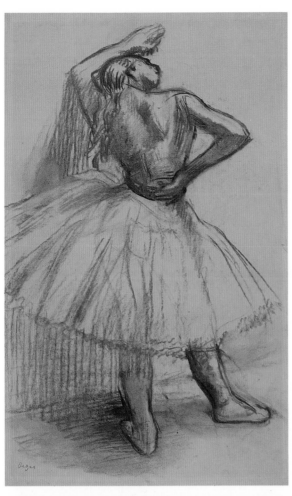

22. Edgar Degas
French, 1834–1917
Ballet Dancer Resting, ca. 1900–1905
Charcoal on cardboard
28 x 20" (70.5 x 51)
Gift of Wright S. Ludington

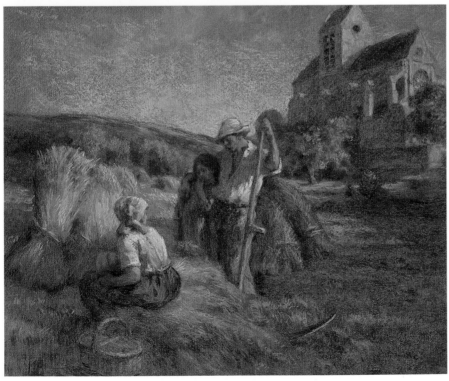

23. Leon Augustin Lhermitte
French, 1844–1925
Harvesters Resting
Pastel
16.5 x 20" (42 x 50.5)
Museum purchase,
The Schott Madonna Fund

24. John Ruskin
English, 1819–1900
Murano, 1876
Graphite on paper
5.5 x 9" (14 x 23)
Bequest of Mrs. Ina T. Campbell

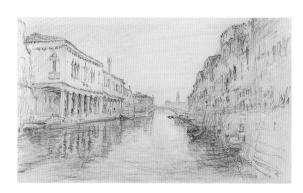

25. Arthur Severn
English, 1842–1931
John Ruskin's Bedroom at Brantwood, 1900
Watercolor and graphite pencil
11 x 16" (28 x 40)
Gift of Mrs. Ina T. Campbell

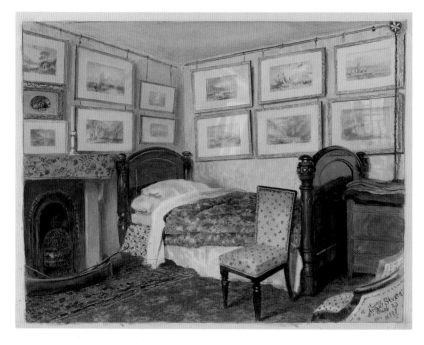

26. Unknown photographer
English, 19th c.
*John Ruskin's Study at Brantwood
as He Rested There, for the Last Time.*
January 24th, 1900
Platinum print
10.5 x 12" (26.5 x 30.5)
Gift of Mrs. Ina T. Campbell

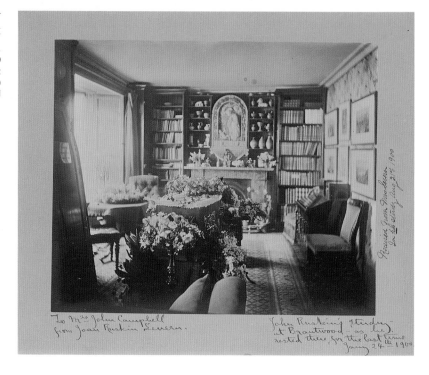

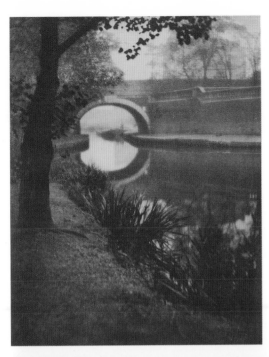

27. Alvin Langdon Coburn
English, 1882–1966
London View
Platinum print
Image 8 x 6″ (20.5 x 15)
Museum purchase, Margaret Mallory Fund

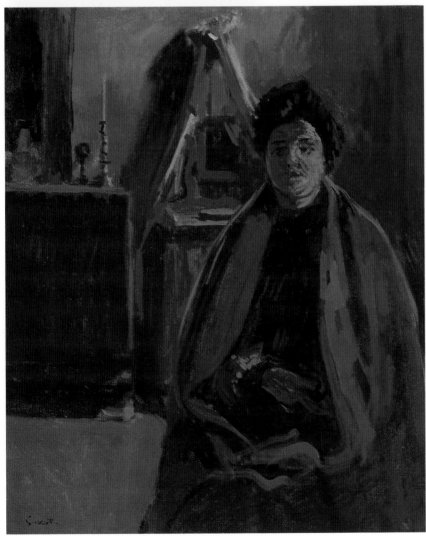

28. Walter Richard Sickert
English, 1860–1942
La Carolina Wearing a Scottish Shawl, 1903–04
Oil on canvas
Image 21.5 x 17.5″ (54.5 x 45)
Gift of Mary and Will Richeson

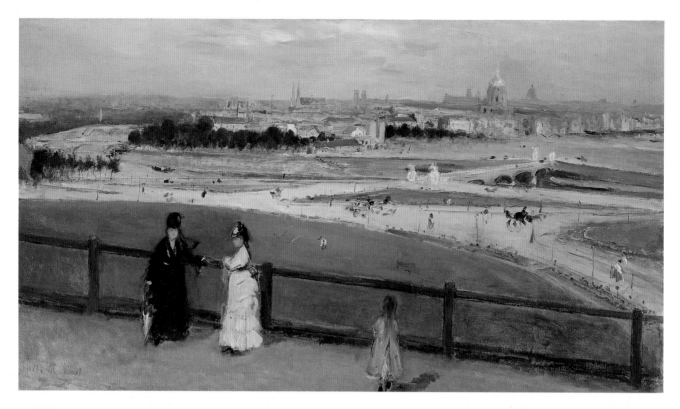

30. Edouard Vuillard
French, 1868–1940
Fuchsias et oeillets d'Inde, ca. 1900
Oil on cardboard
18.5 x 16.5" (47 x 42)
Gift of Millicent A. Rogers in honor of Ala Story

31. Henri Fantin-Latour
French, 1836–1904
Crysanthèmes d'été
Oil on canvas
Image 18 x 15" (45.5 x 38)
Gift of Mary and Leigh Block

29. Berthe Marie Paul Morisot
French, 1841–1895
View of Paris from the Trocadero, 1872
Oil on canvas
18 x 32" (46 x 81.5)
Gift of Mrs. Hugh N. Kirkland

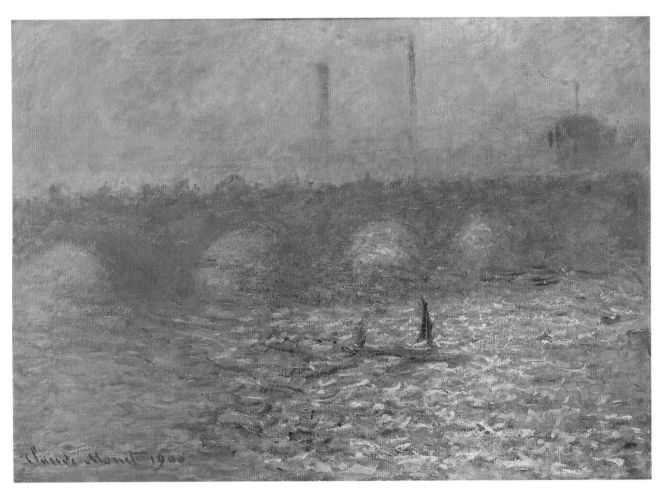

32. Claude Monet
French, 1840–1926
Waterloo Bridge, 1900
Oil on canvas
26 x 36.5" (65.5 x 92.5)
Bequest of Katherine Dexter McCormick
in memory of her husband, Stanley McCormick

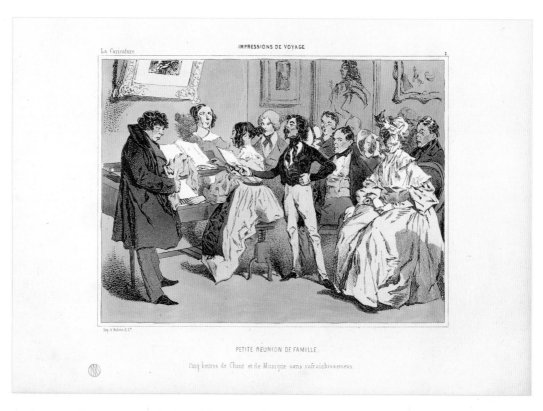

34. Etienne Carjat
French, 1828–1906
Monnier as M. Prudhomme
Woodburytype
Image 9.5 x 7.5" (24 x 19)
Gift of David and Constance Yates

35. Paul Gavarni
French, 1804–1866
Débardeurs on a Balcony, 1847
Brown ink and wash on paper
9.5 x 7" (24 x 18)
Museum purchase, European Deaccessioning Funds

33. Henry Monnier
French, 1799–1877
Petite réunion de famille
(Small family party) from series
Impressions de Voyage, 1839
Hand colored lithograph
Sheet 11 x 14" (28 x 35.5)
Gift of Albert and Dana Broccoli

36. Henri Rivière
French, 1864–1951
La Tempête, 1902
(from series *La Féerie des heures*)
Lithograph
19.5 x 32.5" (49.5 x 82.5)
Gift of Sara and Armond Fields

American

WITH ITS INAUGURAL exhibition, *Painting Today and Yesterday in the United States*, the Museum's first director, Donald Bear, clearly set forth his objectives and emphasized the importance of collecting and exhibiting American art. As one of the organizers of the 1930 New York World's Fair art exhibition, Bear was keenly aware of a new spirit in the art of this country and the need, indeed "...the duty of the American museum...to help create an audience, not only for the artist of national prominence, but for those of local importance, too." Works by George Bellows, Edward Bruce, Charles Sheeler, Yasuo Kuniyoshi, Gilbert Stuart, and Andrew Dasburg all entered the permanent collection in the first year of the Museum's history. These were followed by regular gifts reflecting the current work of Charles Demuth, Milton Avery, and Arthur B. Carles, along with good examples by regional artists Phil Dike, Emil Kosa, Colin Campbell Cooper, and Rico Lebrun (a Museum artist-in-residence during the early forties). By 1942, the first nineteenth-century American painting in the collection, a landscape by Thomas Moran, joined more "contemporary" works and, in 1945, the Museum acquired the celebrated primitive painting *The Buffalo Hunter*. This strong emphasis on collecting American art was unusual among the country's museums at this early date; these pioneer efforts are responsible for the fine reputation enjoyed today by the Museum's American collection.

During the fifties, when abstract art movements were in ascendance, the Museum's American acquisitions reflected instead the already-established modernist idiom, with paintings by Marsden Hartley, Georgia O'Keeffe, and Walt Kuhn. Some years later, gifts to the Donald Bear Memorial Collection enlarged these holdings with works by artists of both regional and national importance such as John Marin, Niles Spencer, Ben Shahn, Howard Warshaw, and June Wayne.

The Museum was especially fortunate with the growing involvement of trustees Sterling Morton and his wife, Preston. Their early gifts of paintings by Prendergast, Alfred Maurer, and Gifford Beal led to the remarkable decision on the part of Mrs. Morton in the late 1950s to form a major collection of American art.

In collaboration with third director, James W. Foster, Jr., she selected pieces that would focus and expand holdings of twentieth-century American art while also creating a comprehensible survey of American painting from 1750 through the first decades of the twentieth century. The Preston Morton Collection of American art, with over forty works given by Mrs. Morton and further gifts from other donors, contains a number of masterpieces of outstanding quality, such as *Morning, Catskill Valley* [pl. 40] and *Mirror Lake, Yosemite Valley* [pl. 42]. Representative works by major nineteenth-century Americans such as William Harnett, Winslow Homer, Severin Roesen, John Peto, Thomas Cole, Jaspar Francis Cropsey, George Inness, and Albert Bierstadt, and early twentieth-century works by Charles Burchfield, Edward Hopper, John Sloan, and Robert Henri beautifully complemented existing holdings.

Formed at a time when critical art historical literature was limited and today's corpus of publications and exhibitions was not available to the collector, the Preston Morton Collection reflects great foresight and generosity. Individual donors have continued to build on this superb foundation, creating notable constellations of work: modernist drawings by Stella, Demuth, Nadelman; nineteenth-century works by Thomas Moran and Frederick Church from the estate of Mrs. Lockwood de Forest; and a major group of drawings and mural studies by Californian Arthur Mathews, to name just a few. These have been supplemented with regular purchases in recent years, expanding further our holdings of nineteenth- and twentieth-century prints and drawings. Recent donors, such as Mary and Will Richeson and Dr. and Mrs. Ronald Lawrence, have added important examples of American Impressionism, along with numerous nineteenth-century paintings, prints, and drawings.

Further plans for enhancing the Museum's exceptional American art holdings include incorporation in the galleries of key examples of decorative arts, and a program to purchase nineteenth-century prints, drawings, and photography. Painting purchases, starting with the recent acquisition of a Luminist seascape by Francis A. Silva, will continue to expand the already strong groupings of landscape and portraiture, as well as develop the less-represented categories of genre and still life.

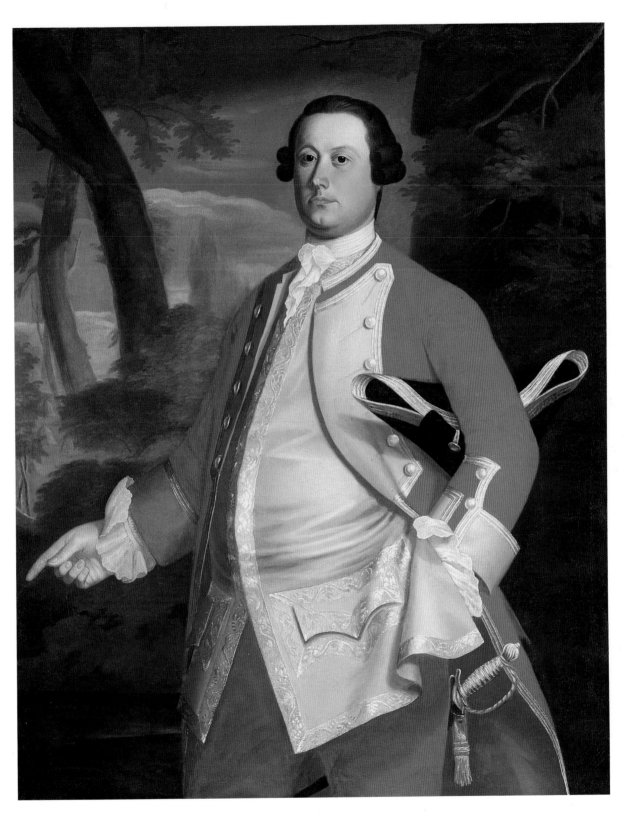

37. John Singleton Copley
American, 1738–1815
Lieutenant Joshua Winslow, 1755
Oil on canvas
50 x 40" (127 x 101.5)
Gift of Mrs. Sterling Morton

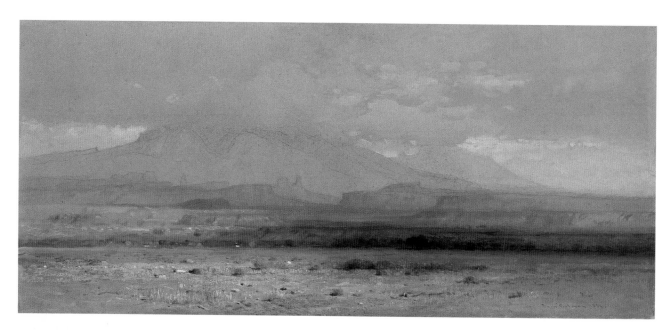

38. Samuel Colman
American, 1832–1920
Tierra La Sal, Borders of the Utah Desert, 1886
Watercolor on paper, laid on cardboard
30 x 13.5" (75.5 x 34.5)
Museum purchase, Deaccessioning Funds
from gifts of Ruth C. Chandler, Emma Constans,
The Helen Park Edwards Bequest, Carolyn Rowland,
and The Susan Trenwith Bequest

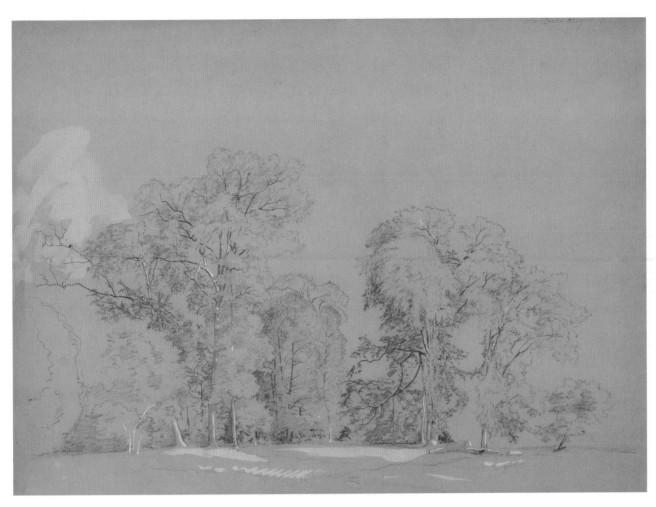

39. David Johnson
American, 1827–1908
Group of Trees, New Berlin
Pencil on paper
10 x 14" (25 x 35)
Museum purchase with funds provided by
Bessemer Trust Co., NYC.

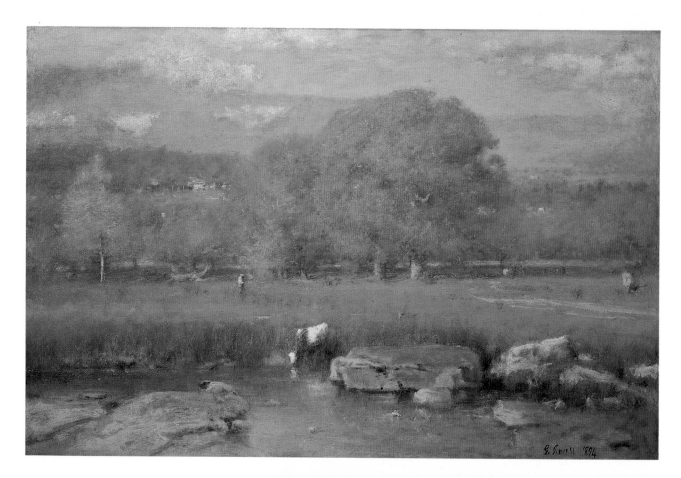

40. George Inness
American, 1825–1894
Morning, Catskill Valley, 1894
Oil on canvas
35.5 x 54" (90 x 136.5)
Gift of Mrs. Sterling Morton to
the Preston Morton Collection

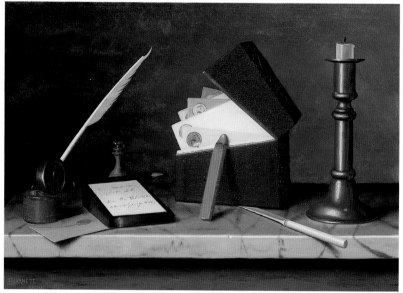

41. William Michael Harnett
American, 1848–1892
Secretary's Table, 1879
Oil on canvas
14 x 20" (35.5 x 51)
Gift of Mrs. Sterling Morton to
the Preston Morton Collection

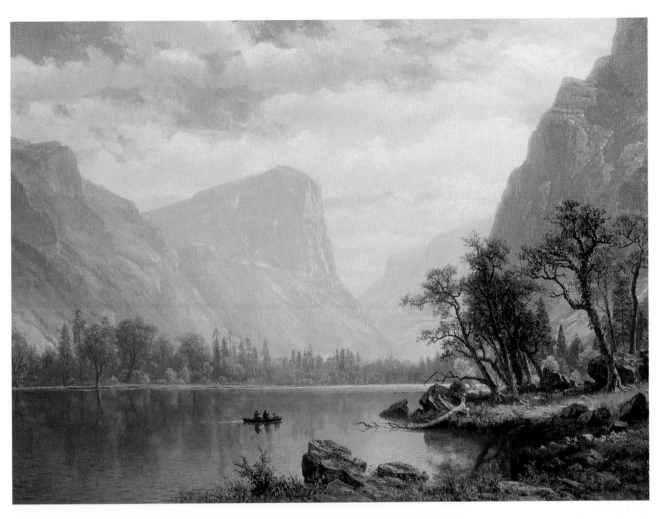

42. Albert Bierstadt
American, 1830–1902
Mirror Lake, Yosemite Valley, 1864
Oil on canvas
22 x 30" (55 x 76.5)
Gift of Mrs. Sterling Morton to
the Preston Morton Collection

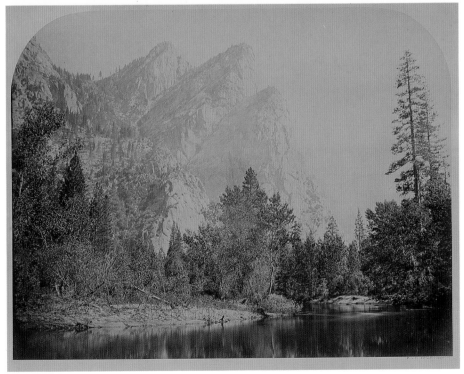

43. Carleton E. Watkins
American, 1829–1916
Three Brothers,
No. 28 Yosemite National Park
Albumen print
Image 16 x 21" (40.5 x 52.5)
Gift of Arthur and Yolanda Steinman

American 43

44. George Wesley Bellows
American, 1882–1925
Steaming Streets, 1908
Oil on canvas
38.5 x 30.5" (97.5 x 77)
Gift of Mrs. Sterling Morton to
the Preston Morton Collection

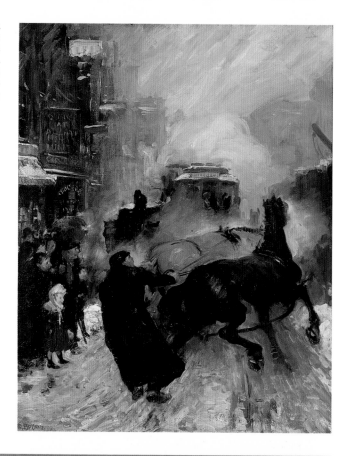

45. Robert Henri
American, 1865–1929
Derricks on the North River, 1902
Oil on canvas
26 x 32" (66 x 81.5)
Museum purchase for the
Preston Morton Collection
with income from the Chalifoux Fund

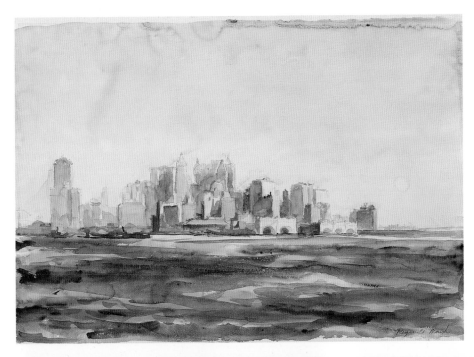

46. Reginald Marsh
American, 1898–1954
Lower Manhattan from Governor's Island, 1926
Wash drawing
Image 14 x 20" (36 x 51)
Museum purchase, The Dicken Fund

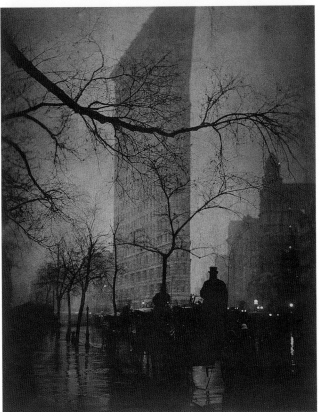

47. Edward Steichen
American, 1879–1973
Flatiron, New York, 1905
Hand-pulled photogravure
Image 10.5 x 12.5" (26 x 31)
Gift of Arthur and Yolanda Steinman

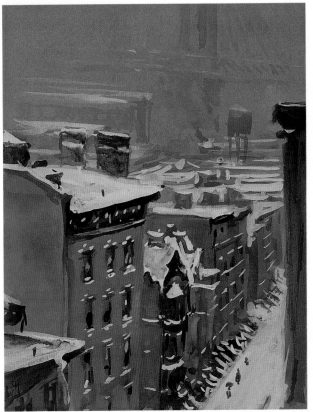

48. Joseph Pennell
American, 1860–1926
Columbia Heights in Snow
Watercolor on paper
13 x 10" (32.5 x 25.5)
Gift of Mr. and Mrs. Julian Ganz, Jr.

49. Arthur Mathews
American, 1860–1945
Discovery of San Francisco Bay, 1913
(sketch for mural, California State Capital,
Sacramento)
Watercolor, pencil on paper
28 x 22" (71 x 55.5)
Gift of Harold Wagner

50. Arthur B. Davies
American, 1862–1928
Italian Landscape, ca. 1925
Oil on canvas
26 x 40" (66 x 101.5)
Gift of Wright S. Ludington

51. Fernand Lungren
American, 1859–1932
Landscape in Lava
Oil on canvas
18 x 36" (45.5 x 91.5)
Gift of Miss Sophie Baylor

52. Edwin Willis Redfield
American, 1869–1965
Landscape of a Snow Scene
Oil on canvas
20.5 x 28.5" (52 x72.5)
Gift of Mary and Will Richeson, Jr.

American 47

53. Charles Demuth
American, 1883–1935
Gladioli and Red Napkin, 1925
Watercolor on paper
18 x 12″ (45.5 x 30.5)
Gift of Wright S. Ludington

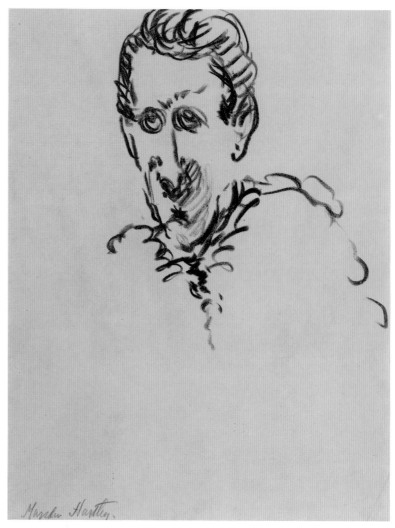

54. Marsden Hartley
American, 1878–1943
Self-Portrait
Conte crayon on paper
11.5 x 9″ (28.5 x 22)
Gift of Mr. Frank Perls

55. Marsden Hartley
American, 1878–1943
Still Life, ca. 1929/30
Oil on cardboard
26 x 19″ (65.5 x 47.5)
Gift of Wright S. Ludington

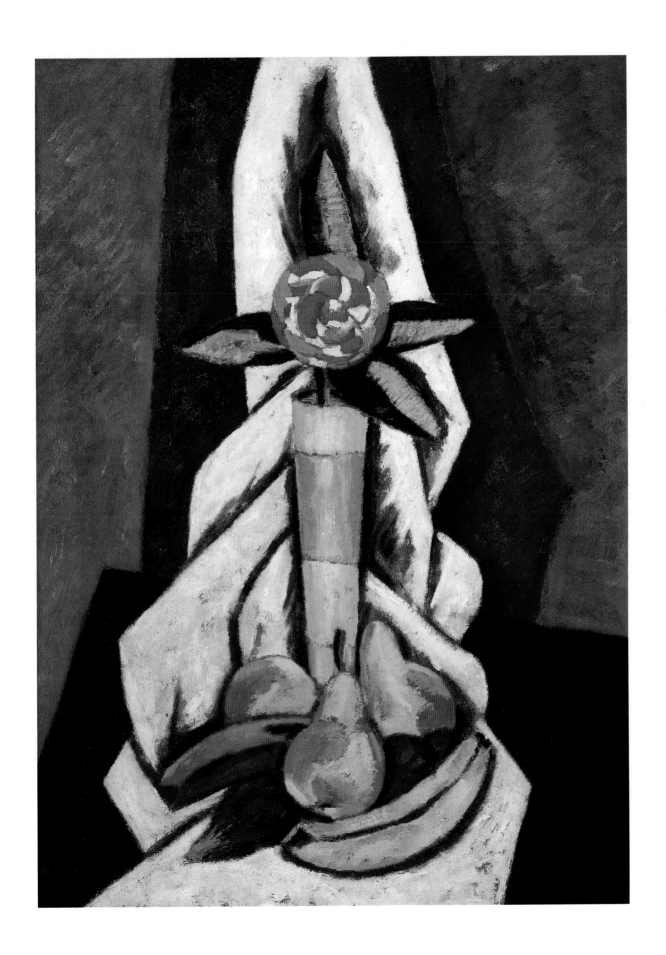

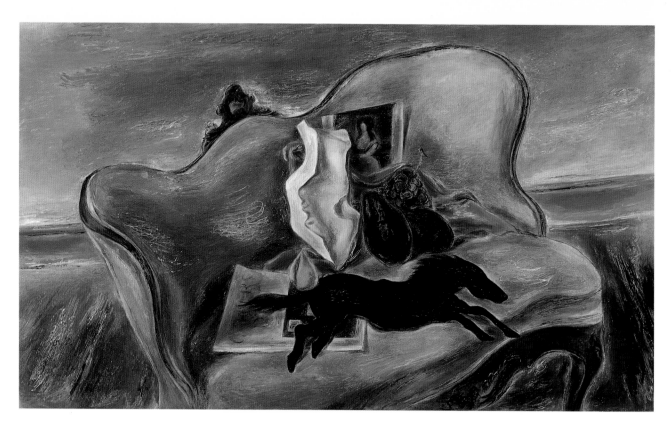

56. Yasuo Kuniyoshi
American, b. 1893
Weathervane and Objects on a Sofa, 1933
Oil on canvas
35.5 x 60" (89.5 x 152.5)
Gift of Wright S. Ludington

57. Stanton MacDonald-Wright
American, 1890–1973
Yin Sychromy No. 3, 1930
Oil on canvas
34 x 40" (86.5 x 101.5)
Gift of Mrs. John D. Graham

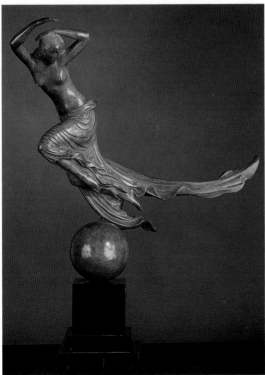

58. Paul Manship
American, 1885–1966
Flight of Night, 1916
Bronze sculpture, ed. 20
17.5" (44)
Gift of Mrs. George M. Newell

American 51

59. John Marin
American, 1875–1953
Midtown Construction, ca. 1928
Pencil drawing
Image 7 x 9″ (18 x 22),
Museum purchase, The Estate of Carroll Donner

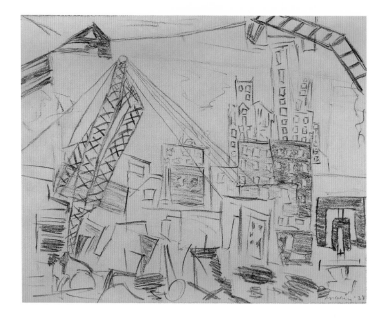

60. John Marin
American, 1877–1943
Mid Town Construction, 1928
Watercolor and ink on paper
22 x 26.5″ (55 x 66.5)
Gift of Wright S. Ludington and the Acquisitions Fund

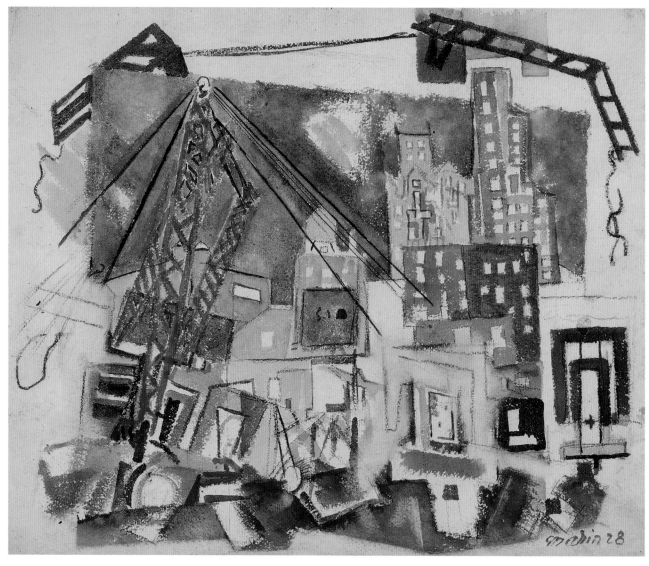

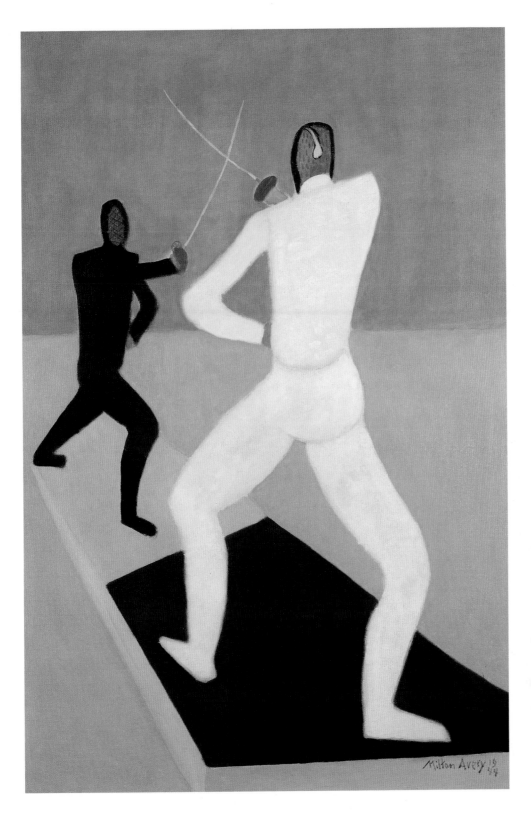

61. Milton Avery
American, 1885–1965
Fencers, 1944
Oil on canvas
48.5 x 32.5" (122.5 x 82)
Given in Memory of Maximilian von Romberg by
Emily Hall, Baroness von Romberg

62. Edward Weston
American, 1886–1958
Abandoned Gas Station, Mojave Desert, 1937
Silver gelatin print
7.5 x 9.5" (19 x 24)
Gift of Mary D. Darby

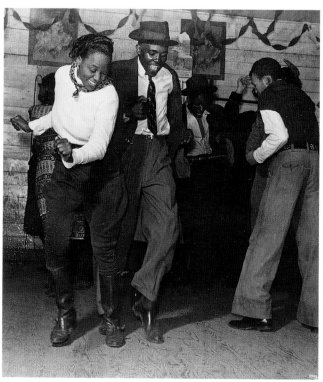

63. Marion Post Wolcott
American, 1920–1990
Jitterbugging in "Juke Joint",
Clarkdale, Miss., 1939
Silver gelatin print
13 x 11" (32.5 x 28)
Museum purchase with funds contributed
by Mercedes Eichholz

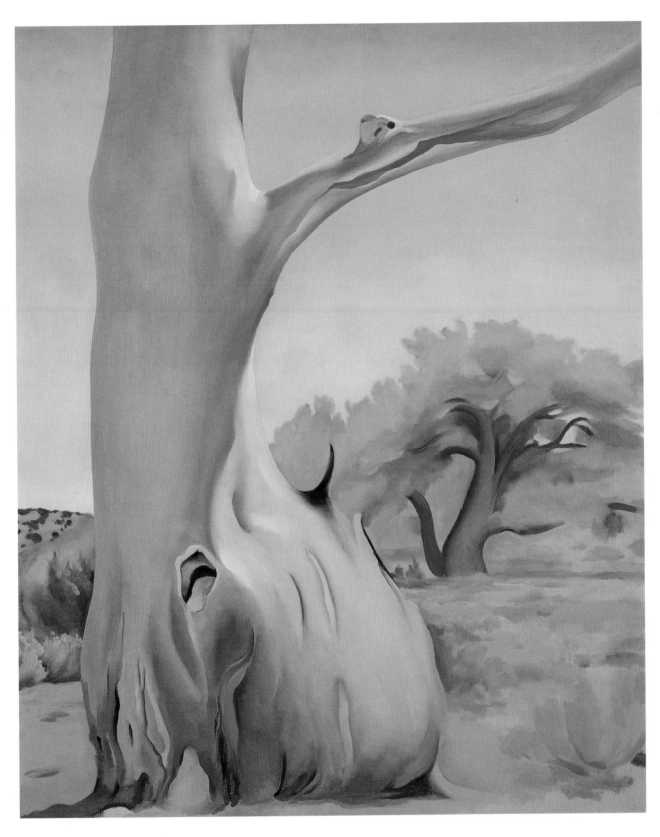

64. Georgia O'Keeffe
American, 1887–1986
*Dead Cottonwood Tree, Abiquiu,
New Mexico,* 1943
Oil on canvas
36 x 30″ (91.5 x 76)
Gift of Mrs. Gary Cooper

International Modernism

THE MUSEUM'S collection of international modern art, which includes painting, sculpture, photography, drawings, prints and other works on paper dating from approximately the turn of the century through the end of World War II, was inspired in large part by the efforts and interest of its second director, Ala Story. The Ala Story Gallery of International Modern Art was dedicated in 1985 for the purpose of presenting this important and still growing body of work on a regular and annual basis. A sizable portion of the collection was the result of gifts to the Ala Story Collection and of acquisitions made through the Ala Story Purchase Fund, both established by her friends and admirers after she retired from the Museum in 1957. In addition to Ala Story herself, important donors of work in this area have been Margaret Mallory, Wright S. Ludington, Dr. and Mrs. MacKinley Helm, Mr. and Mrs. Joseph Halle Schaffner, and Mr. and Mrs. Warren Tremaine, among others.

One of the major strengths of the collection is in the body of over 1,400 twentieth-century North American, European, and Latin American works on paper. The rapid evolution toward abstraction during the first several decades of the century is particularly well demonstrated in these holdings. For example, *Bathers* by George Rouault [pl. 65] indicates a move away from the Impressionist legacy of the direct observation of nature toward a greater interest in pictorial clarity and formal organization. A work of only a few years later, *Study for the Woman in Blue* by Fernand Léger [pl. 66], shows the Cubist interest in geometric structure and further simplification of form.

A number of styles based on Cubist design principles emerged in the early 1910s, among them Orphism, Futurism, and Vorticism. *Portrait of Ezra Pound* by Wyndham Lewis [pl. 71] is a prime example of Vorticist drawing, both in its formal language and in its subject, the poet, who was a close friend of Lewis'. Pound coined the term Vorticism to designate the British movement that flowered just before World War I and sought to represent the dynamic forces of modern life within the geometric manner of Cubism. Recent acquisitions of works by Lewis and David Bomberg point to the Museum's continuing interest in twentieth-century British art—an interest again inspired by Ala Story. After beginning her career in England, Story moved to the United States and established the American British Art Center in New York to introduce contemporary British artists to the art audience in this country.

The visual language of geometric forms was quickly becoming an international one by the early twenties, spread by the influence of the Russian Constructivists and promoted by the Bauhaus, both while it was headquartered in Germany and, later, after its move to this country. The collection includes examples of Bauhaus teachers László Moholy-Nagy, Wassily Kandinsky [*Linie-Fleck*, pl. 72], and Herbert Bayer [*Self-Portrait*, pl. 84], all of whom promoted a unity of the arts and a reconciliation of the forms of art with those of life in the modern machine age.

Equally well represented in the collection, along with the array of abstract modes, are the landmark figurative movements of the first half of the century. Picasso and Matisse, perhaps the two most important figurative artists of the modern era, are both present in multiple holdings. Picasso's career is spanned by a sizable group of drawings and prints, including a 1906 pen and

ink self-portrait, two monumental figure drawings from the late teens (one being *Woman with a Pitcher*, pl. 75), and later examples from his minotaur and bullfight themes. In Germany and Austria, a variety of artists sought emotional expression through the use of intense, symbolic color and exaggerated form. *Portrait of the Artist's Wife, Edith* by Viennese Expressionist Egon Schiele [pl. 70] is milder psychologically than some of the artist's other portraits but, nevertheless, demonstrates his sure and energetic line. In *The Lovers (Self-Portrait with His Wife, Ada)* [pl. 69], Emil Nolde has used intense colors and bold graphic marks to heighten the emotional aspect of the two subjects' relationship. Examples by Alexej Jawlensky, Käthe Kollwitz, George Grosz and Max Pechstein further round out this impressive group of expressionist artworks.

One of the most important post-World War I movements, Surrealism was practiced by a highly organized group of artists and writers who formed around André Breton, poet and author of the *First Surrealist Manifesto* in 1924. In addition to several noteworthy drawings from the 1930s, Salvador Dali, a major Surrealist figure, is represented by a significant painting, *Honey is Sweeter Than Blood* [pl. 76]. The enigmatic character and visual surprise of the subject, along with the meticulous, old master-like technique, combine in a truly representative example of Dali himself and Surrealism in general. In a slightly different vein, Joan Miró in his drawing, *Woman Fleeing Fire* [pl. 77] intensifies the nightmarish quality of the portrayed event through formal distortion and tonal contrast. The influence of Surrealism was widespread, extending throughout Europe and the Americas and to artists who were never part of the official group; its impact can also be seen in the work of British artists Henry Moore [*Shelter Scene*, pl. 78], and John Tunnard

[*The Last Day*, pl. 79], Mexican painter David Alfaro Siqueiros [*The Hill of the Dead*, pl. 80], and Mexican photographer Manuel Alvarez Bravo [*Calabaza y Carscol*, pl. 85].

Among other Latin American artists included in the collection are two of the most noted of the Mexican muralists: José Clemente Orozco and Diego Rivera. Orozco's *Female Figure Study* [pl. 82] is a pencil study for the figure of La Malinche, the legendary Aztec mistress of Cortez, featured in one of the artist's murals in Mexico City. In *Tehuantepec Woman* [pl. 83], Diego Rivera uses simplified, hieratic forms to suggest the dignity of his subject, very much in keeping with the cultural pride that characterized the mural movement. The Museum's Latin American collection, though small, has some key examples that will, with time, be augmented by contemporary additions.

The currently prevailing view of the history of modern art casts it as a succession of dominant artistic movements, and the Museum's holdings fortunately represent many of the major stylistic and theoretical developments of the first five decades of the century. Plans for future growth in this area are to build upon existing strengths—Austrian and German Expressionism, and Cubist-influenced styles such as Futurism and Vorticism, Constructivism, and Surrealism—while simultaneously working toward key additions that will further strengthen the collection.

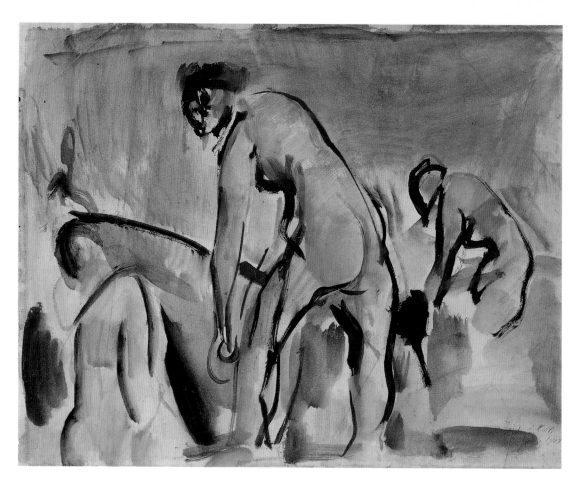

65. Georges Rouault
French, 1871–1958
Bathers, 1908
19 x 24" (48 x 61)
Bequest of Dr. MacKinley Helm

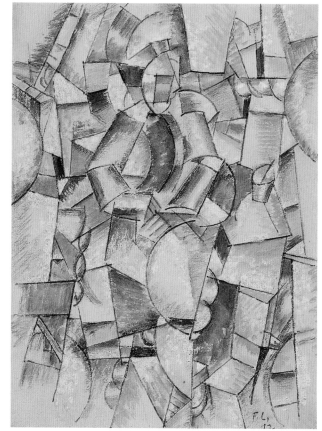

66. Fernand Léger
French, 1881–1955
Study for The Woman In Blue, 1912
Gouache on paper
14.5 x 10.5" (37 x 26.5)
Gift of Leigh B. Block

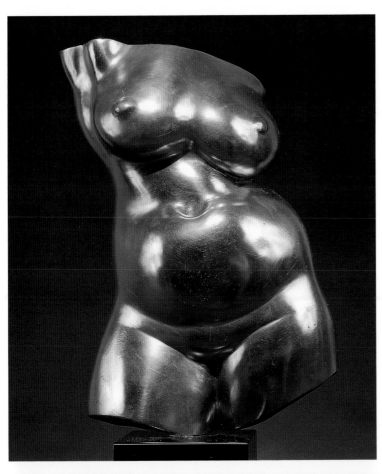

67. Gaston Lachaise
American (b. France), 1882–1935
Classic Torso, 1928
Bronze
17.5 x 7 x 6" (45 x 18 x 15.5)
Gift of Spencer Kellog, Jr.

68. Charles Despiau
French, 1874–1946
Reclining Nude
Bronze
13.5 x 4 x 23" (34.5 x 9.5 x 58.5)
Gift of Arthur Sachs

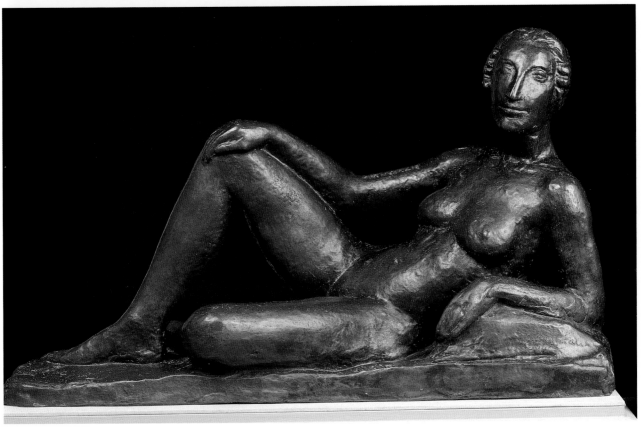

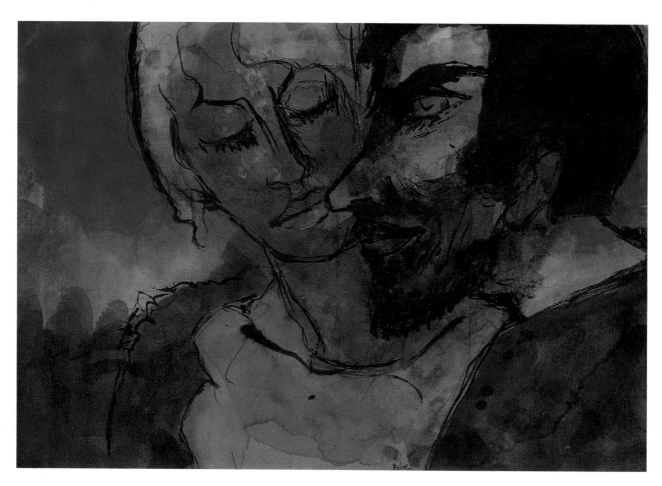

69. Emil Nolde
German, 1867–1956
The Lovers (Self Portrait with His Wife, Ada), 1932
Watercolor on paper
13.5 x 19.5" (33.5 x 49.5)
Promised gift

70. Egon Schiele
Austrian, 1890–1918
Portrait of the Artist's Wife, Edith, 1915
Pencil on paper
18 x 12.5" (45.5 x 31)
Gift of Wright S. Ludington

71. Wyndham Lewis
Nova Scotian (active England), 1884–1957
Portrait of Ezra Pound
Charcoal and black grease pencil on paper
14 x 10" (36 x 25.5)
Gift of Wright S. Ludington

International Modernism 61

72. Wassily Kandinsky
Russian, 1866–1944
Linie-Fleck, 1927
Oil on cardboard
18 x 26.5" (45 x66.5)
Gift of Mr. and Mrs. Ira Gershwin

73. Kurt Schwitters
German, 1887–1948
Marae, 1936
Collage on cardboard
8 x 6" (20 x 15)
Museum purchase

74. Lyonel Feininger
American, 1871–1956
Gelmeroda
Pen, ink and watercolor on paper
10 x 13" (25 x 33.5)
Gift of Mrs. McLennan Morse

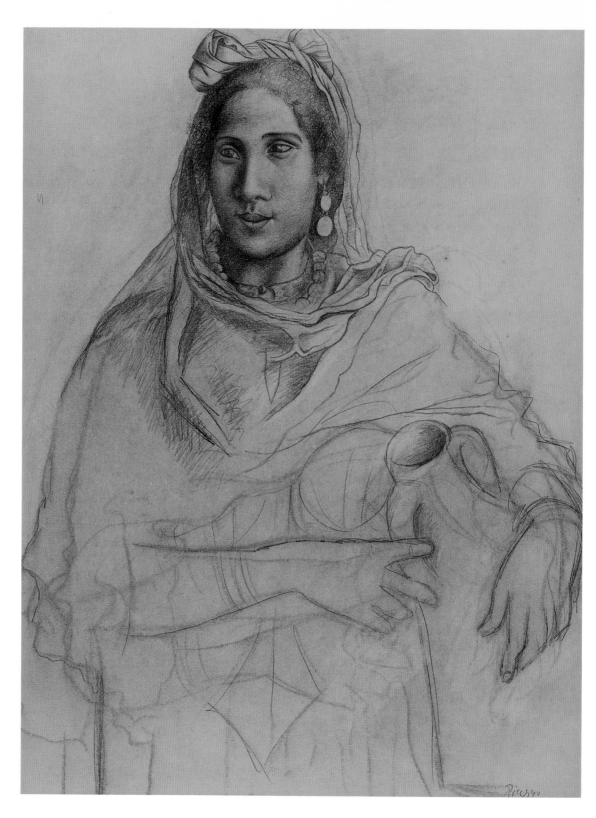

75. Pablo Picasso
Spanish, 1881–1973
Woman with a Pitcher, 1919
Pencil over charcoal on paper
25.5 x 19" (65 x 48.5)
Gift of Wright S. Ludington

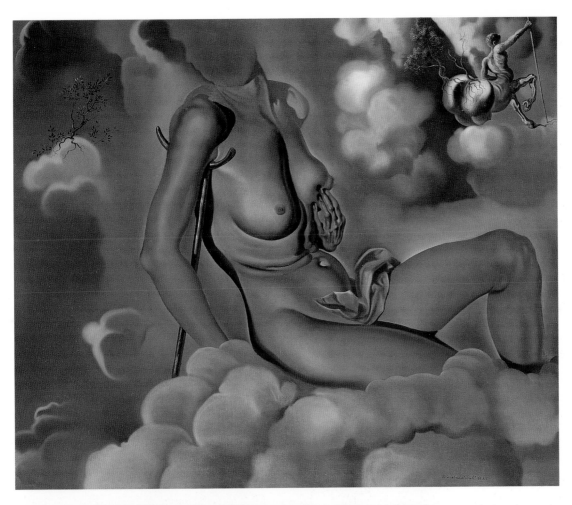

76. Salvador Dali
Spanish, 1904–1989
Honey Is Sweeter Than Blood, 1941
Oil on canvas
20 x 24" (51 x 24)
Gift of Mr. and Mrs. Warren Tremaine

77. Joan Miró
Spanish, 1893–1983
Woman Fleeing Fire, 1939
Pencil, gouache on paper
13 x 16" (32.5 x 40)
Gift of Wright S. Ludington

78. Henry Moore
English, 1898–1986
Shelter Scene, 1941
Pen and ink wash, wax crayon on paper
7 x 10" (18 x 25.5)
Gift of Mrs. Ninfa Valvo
in memory of Donald Bear

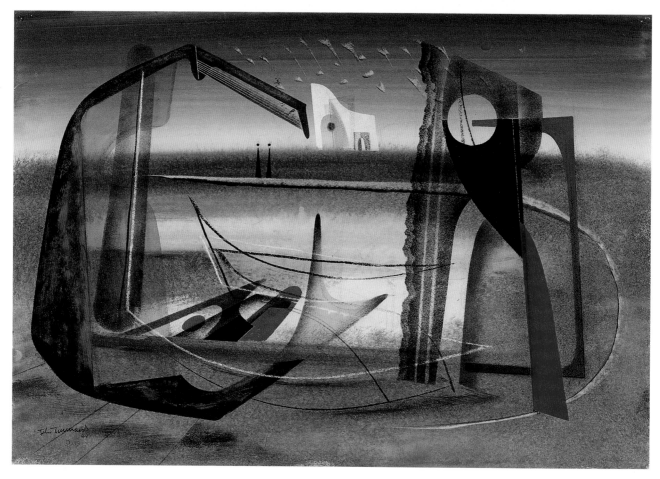

79. John Tunnard
English, b. 1900
The Last Day, 1944
Pastel, wash, gouache, crayon,
pen and ink on rag paper
15 x 22" (38 x 56)
Gift of Wright S. Ludington

80. David Alfaro Siqueiros
Mexican, 1896–1974
The Hill of the Dead, 1944
Ducco on board
34.5 x 27″ (87 x 68.5)
Gift of Mrs. MacKinley Helm

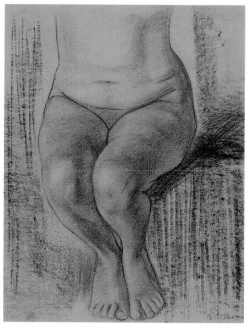

81. Paul Strand
American, 1890–1976
Woman – Patzcuaro, 1933
Photogravure
6.5 x 5" (16 x 12.5)
Gift of Arthur and Yolanda
Steinman

82. José Clemente Orozco
Mexican, 1883–1949
Female Figure Study
Pencil
22.5 x 17.5 (57 x44.5)
Anonymous Donor

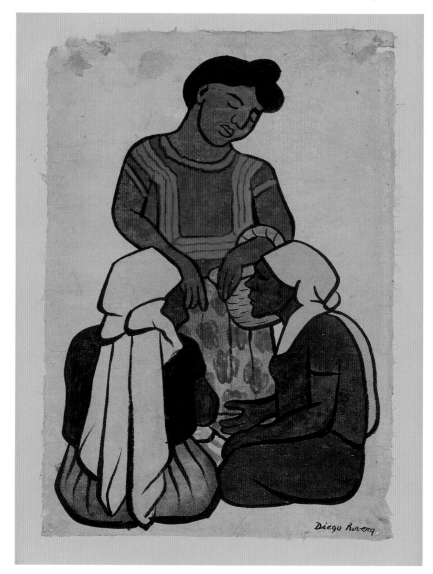

83. Diego Rivera
Mexican, 1886–1957
Tehuantepec Woman
Watercolor on paper
17 x 13" (43.5 x 32.5)
Gift of Dr. and Mrs. MacKinley Helm
in honor of Ala Story

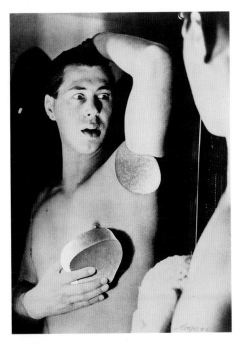

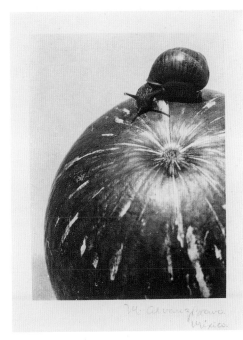

84. Herbert Bayer
Austrian (active America), 1900–1985
Self-Portrait, 1932
Photomontage
Sheet 14 x 11" (35 x 28)
Image 13.5 x 9.5" (34 x 24)
Museum purchase with funds provided
by Chalifoux Fund and Auction/Auction,
courtesy of Margaret Mallory

85. Manuel Alvarez Bravo
Mexican, b. 1902
Calabaza y Carscol, ca. 1929
Platinum print
Sheet 12 x 10" (31 x 25.5)
Image 6 x 4.5" (6.5 x 11.5)
Gift of Mr. and Mrs. Lorenzo Hernandez
in honor of their son, Lorenzo Nicolas
Hernandez

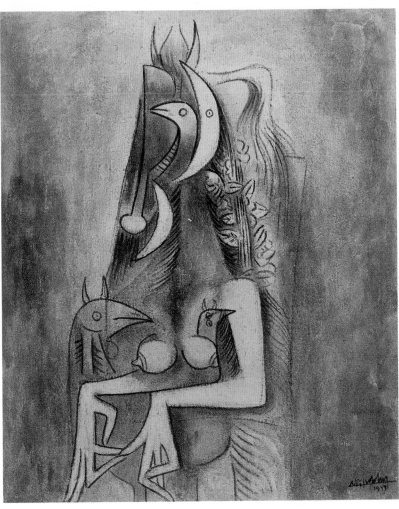

86. Wilfredo Lam
Cuban, 1902–1982
Personage, 1947
Oil on burlap
43 x 36" (109.5 x 91.5)
Gift of Wright S. Ludington

Contemporary

LIKE ANY contemporary collection, that of the Santa Barbara Museum of Art is continually evolving. The exhibition and acquisition of the art of the present has been a part of the Museum's mission since its inception, when Donald Bear, the first director, organized one-person exhibitions of such artists as Mark Rothko, Morris Graves, and Lyonel Feininger, photographers Edward Weston, Ansel Adams, and Aaron Siskind, and California artists Douglass Parshall and Rico Lebrun. In some cases the Museum's exhibitions were among the first of their careers for artists who later gained national and international reputations. As part of her abiding interest in and dedication to international modern art, Bear's successor, Ala Story, sought to discover and exhibit the work of young American artists. In 1955, she established the Pacific Coast Biennial Exhibitions, from which several important works, including paintings by Mark Tobey [pl. 89] and Richard Diebenkorn [pl. 90], were purchased for the collection. Although the Biennials were discontinued, the Museum remains committed to the presentation of contemporary art, both regional and otherwise, as well as to the practice of acquiring works by artists who have been featured in exhibitions. Recently, for example, interest generated in the work of New York artist Scott Richter, when it was included in a group exhibition of current sculpture, resulted in the purchase of *Pope* [pl. 103] by the Friends of Contemporary Art, a Museum support group.

The contemporary collection includes painting, sculpture, photography, works on paper, and mixed media works, with a particular emphasis on American artists of the fifties and sixties. While noticeable gaps exist, particularly in post-war American painting (an area difficult to address in today's market), a number of the important developments in art from the 1950s to the present are represented. The Museum's goals for expanding the collection are multifold: to fill the gaps where possible; to acquire a broader selection of European art; and to concentrate on acquiring works by younger artists.

The story of contemporary art after World War II begins with the shift of activity from Paris to New York. There, Hans Hofmann, a highly influential teacher and one of the key figures in the development of postwar American painting, helped to establish Abstract Expressionism as the predominant movement of the time. *Simplex Munditiis* [pl. 87], although a somewhat later composition, is yet a prime articulation of Hofmann's theories, which espoused the use of areas of color to organize the picture plane and to suggest depth while simultaneously asserting the flatness of the canvas surface. *Composition* [pl. 88] by Adolph Gottlieb, a member of the first generation of the so-called New York School, also reflects the growing interest in the over-all treatment of the picture plane and development of a personal, expressive vocabulary of pictorial forms.

While Abstract Expressionism held the dominant role in artistic theory and practice throughout the fifties, it was by no means the only option; figurative painting was hardly an unpracticed approach. In Northern California, David Park and Richard Diebenkorn were two of the most important members of the group known as the Bay Area Figurative artists. *Three Women* by Park [pl. 91] and *Woman and Checkerboard* [pl. 90] by Diebenkorn, exemplify the artists' synthesis of the gestural brushwork and expressive color of Abstract Expressionism with figurative content. Other Bay Area artists represented in the collection include William Theophilus Brown, Peter Voulkos [pl. 92], and Robert

Arneson [pl. 93].

In Southern California, a number of alternative sensibilities were also emerging. John McLaughlin was the leading figure in a group of four artists who came to be called the Abstract Classicists (the other three—Karl Benjamin, Lorser Feitelson and Frederick Hammersley—are also represented in the collection). As can be seen in *Number 5* [pl. 105] by McLaughlin, these artists sought a formal purity through the use of hard-edged geometric shapes and flat, unmodulated color. The next generation of Southern California artists is also well represented. Larry Bell, John McCracken, Billy Al Bengston, and Ron Davis, among others, began experimenting with the use of industrial non-art materials to produce work that had a new slick, almost commercial, finish. In such works as the characteristic *Stalls* [pl. 106], for example, Ron Davis used polyester resin and fiberglass in a shaped construction which resides somewhere between painting and sculpture.

A widespread interest in the sheer perceptual qualities of form and color which gained momentum during the 1960s is also evident in the work of Bridget Riley [pl. 109], one of the main proponents of European Op Art, Richard Anuskiewicz, and Al Held. Held [pl. 110] turned from earlier, more expressive work to the controlled orchestration of line and color in creating a sense of deep mathematical space. Rounding out the collection, and bringing it up to date, are splendid monotypes by Sam Francis [pl. 102] and Sean Scully [pl. 104], both produced at the experimental Garner Tullis Workshop here in Santa Barbara; David Hockney's large photographic collage, *Brooklyn Bridge #7* [pl. 98]; a quintessential late Isamu Noguchi sculpture, *Ceremony* [pl. 101]; and *Dbl. OR* [pl. 107], Jud Fine's witty and complex painting-cum-object.

It has been possible over the years to find creative ways to extend the limited purchase funds available, and to enlist the support of various groups in acquiring works for the collection. Matching grants in 1979 and 1981 from the National Endowment for the Arts Museum Purchase Plan made possible the addition of a variety of works such as *Stalls* by Ron Davis, a major glass sculpture by Larry Bell, a portfolio of color lithographs by James Rosenquist and a sizable group of photographs, including work by Lee Friedlander, Jo Ann Callis, Judy Dater and Ruth Thorne-Thomsen [pl. 96]. The Women's Board has now made several purchases for the collection; their 1980 acquisition of *The Pont Neuf, Wrapped (Project for Paris)* [pl. 99] by Christo, has proven to be a particularly important addition. The Friends of Contemporary Art are committed to at least one annual purchase, usually with a focus on contemporary sculpture. From 1974 to 1978, the Museum operated the Contemporary Graphics Center for the exhibition and sale of prints and drawings. Purchases during that time and ongoing contributions to the Contemporary Graphics Center/William Dole Fund Collection have been instrumental in building a fine group of graphic works, including *Souvenir I* [pl. 97] by Jasper Johns and works by Sol Le Witt, William Wiley, Ed Ruscha, and Sam Francis. Several Museum-sponsored collectors trips, to New York and Europe, have resulted in the acquisition of works; the 1989 trip to France added several works by contemporary French artists, including Jean Le Gac and Pascal Kern. Finally, the generosity of individual donors has helped substantially to broaden the collection in the area of contemporary art; among particular supporters have been Leigh and Mary Block, Barry and Gail Berkus, Arthur and Yolanda Steinman, and the Charles and Mildred Bloom Memorial Fund.

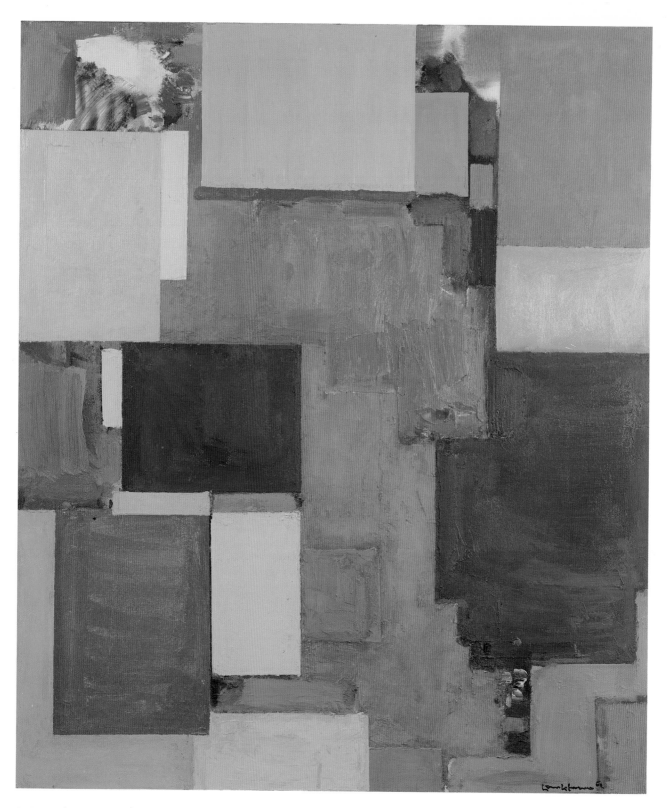

87. Hans Hofmann
American (b. Germany), 1880–1966
Simplex Munditiis, 1962
Oil on canvas
84 x 72″ (213.5 x 183)
Gift of Mr. and Mrs. Hans Hofmann

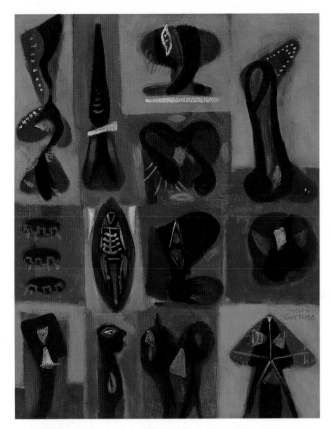

88. Adolph Gottlieb
American, 1903–1974
Composition, 1947
Oil on canvas
32 x 25" (81.5 x 63.5)
Gift of Burt Kleiner

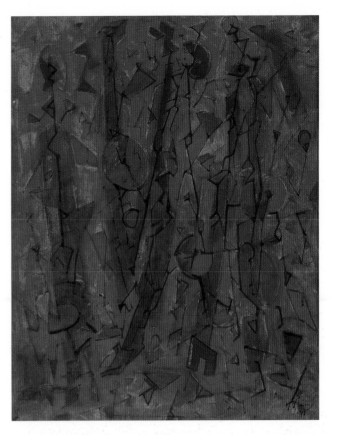

89. Mark Tobey
American, 1890–1976
Pacific Rhythms, 1948
Tempera on paper
26 x 20.5" (66 x 51.5)
Museum purchase,
First Pacific Coast Biennial Exhibition

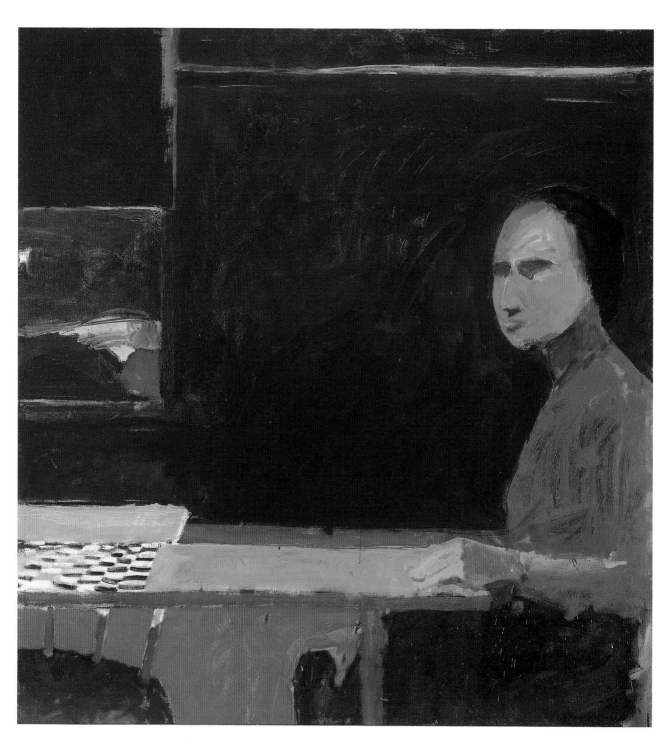

90. Richard Diebenkorn
American, b. 1922
Woman And Checkerboard, 1956
Oil on canvas
59 x 56" (150 x 142)
Museum purchase,
Second Pacific Coast Biennial Exhibition

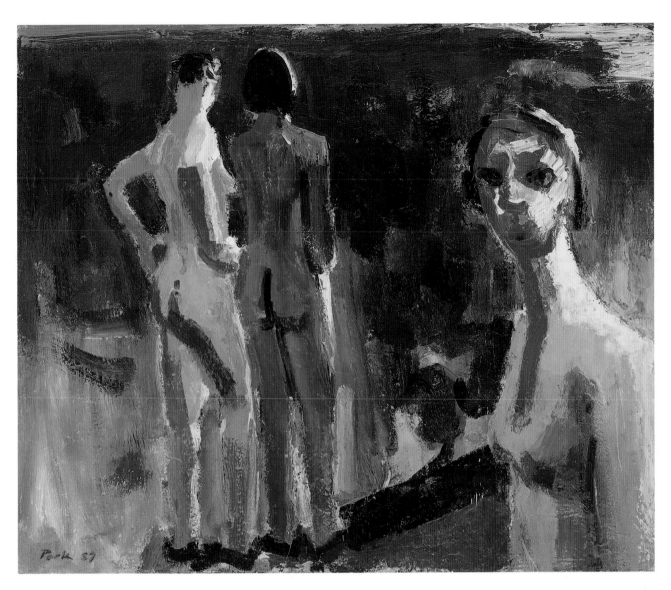

91. David Park
American, 1911–1960
Three Women, 1957
Oil on canvas
48 x 58″ (122 x 147.5)
Gift of Mrs. K. W. Tremaine in honor of
Mr. Paul Mills' appointment as Director

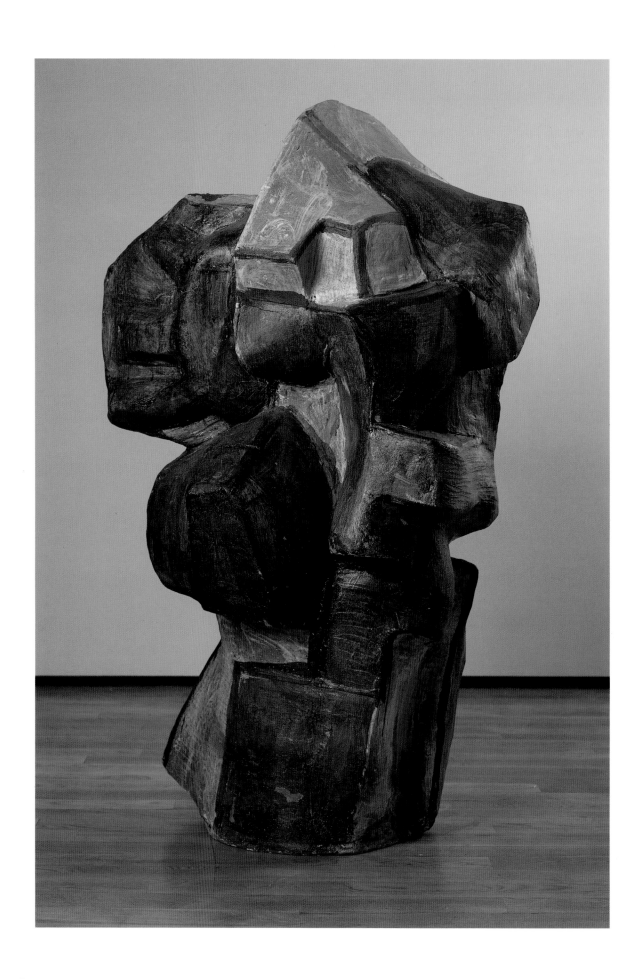

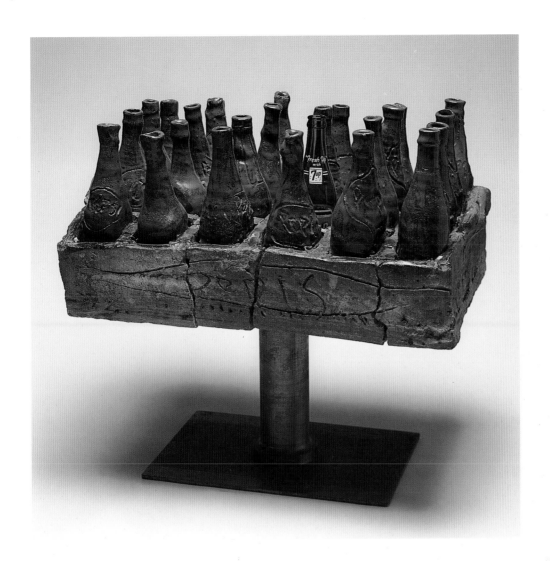

93. Robert Arneson
American, b. 1930
Case Of Bottles, 1963
Ceramic and glass
10.5 x 22 x 15" (26.5 x 56 x 38)
Gift of Mr. and Mrs. Stanley Sheinbaum

92. Peter Voulkos
American, b. 1924
Sitting Bull, 1959
Stoneware, wheel and paddled parts,
slip and glaze
69 x 37 x 37" (175.5 x 94 x 94)
Bequest of Hans G.M. de Schulthess

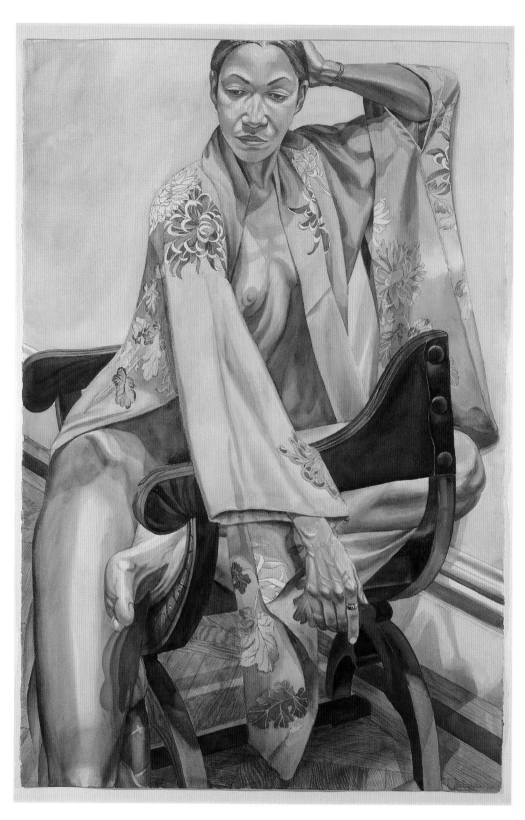

94. Philip Pearlstein
American, b. 1924
Female Model in Green Kimono On Savonarola Chair, 1979
Watercolor on paper
59.5 x 40" (151.5 x 101.5)
Museum purchase with funds provided by Auction/Auction,
courtesy of Margaret Mallory

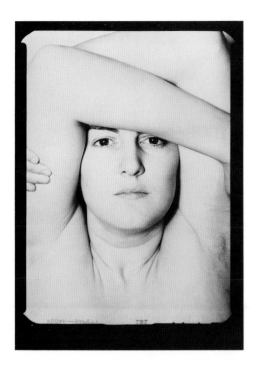

95. Harry Callahan
American, b. 1912
Eleanor, 1947
Black and white gelatin silver print
8 x 5" (20.5 x 12.5)
Gift of Arthur and Yolanda Steinman

96. Ruth Thorne-Thomsen
American, b. 1934
Head, 1979
Tone black and white silver print
Sheet 4.5 x 5" (11 x 13);
Image 3.5 x 4.5" (9 x 11)
Gift of the artist

97. Jasper Johns
American, b. 1930
Souvenir I, 1972
Lithograph
Sheet 38.5 x 29" (97 x 73);
Plate 36.5 x 21.5" (92.5 x 54)
Gift of Betty and Bob Klausner to the Contemporary
Graphics Center/William Dole Fund Collection

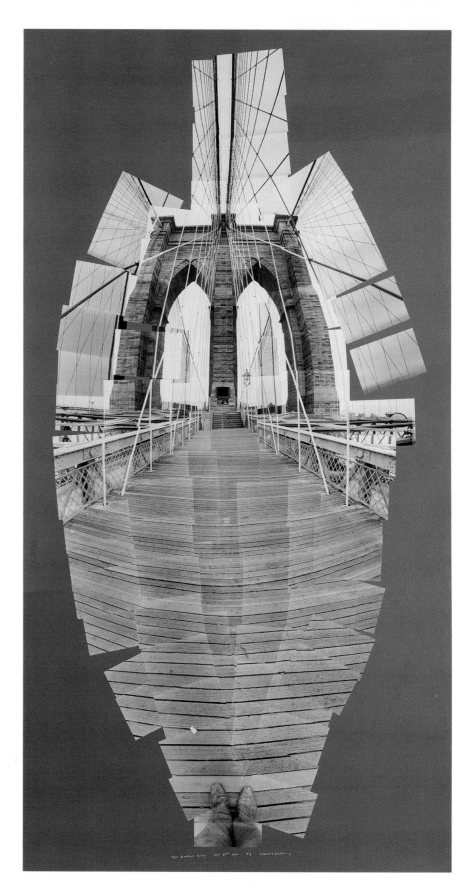

98. David Hockney
English (active America), b. 1937
Brooklyn Bridge #7, 1982
Photographic collage
Sheet 109 x 58" (277 x 147.5)
Museum purchase,
The Mary and Leigh Block Fund

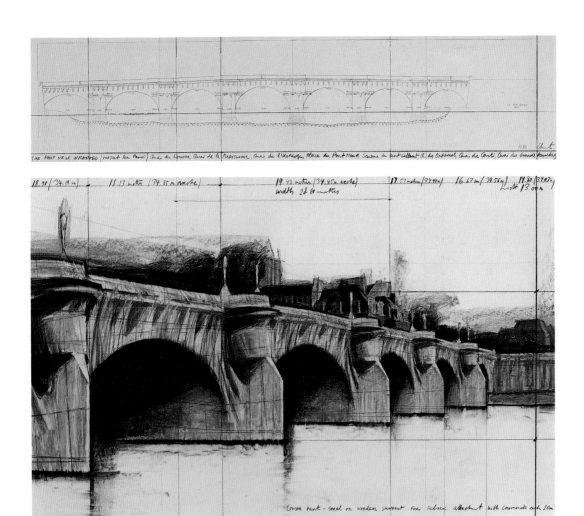

THE PONT NEUF WRAPPED (PROJECT FOR PARIS) Quai du Louvre, Quai de la Mégisserie, Quai de l'Horloge, Place du Pont Neuf, Square du Vert Gallant (Î. des Orfèvres), Quai de Conti, Quai des Grands Augustins

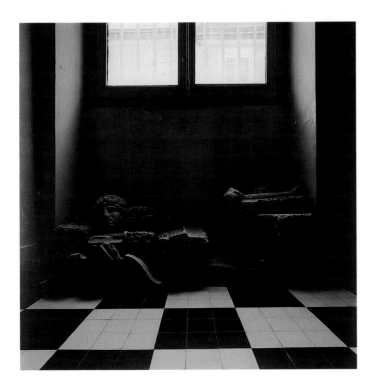

99. Christo (Javacheff)
Bulgarian (active America), b. 1935
*The Pont Neuf, Wrapped
(Project For Paris),* 1980
Pastel, charcoal and pencil on paper
a. 15 x 65" (38 x 165)
b. 42 x 65" (106.5 x 165)
Gift of the Women's Board
in memory of Virginia Williams

100. Richard Ross
American, b. 1947
Chateau Nun, France, 1983
Color coupler print
As framed 29 x 29" (73.5 x 73.5)
Gift of Barry and Gail Berkus

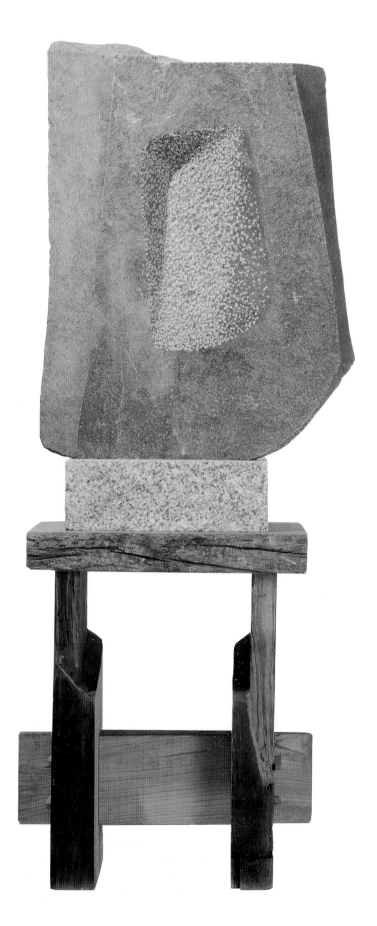

101. Isamu Noguchi
American, 1904–1988
Ceremony, 1982
Jasper, granite, and wood
Jasper 37 x 28.5 x 7.5″ (93.5 x 72.5 x 18.5);
Granite 6 x 18 x 13″ (15 x 45.5 x 33);
Wood 31 x 26.5 x 17.5″ (78 x 66.5 x 45)
Museum purchase,
The Mary and Leigh Block Fund

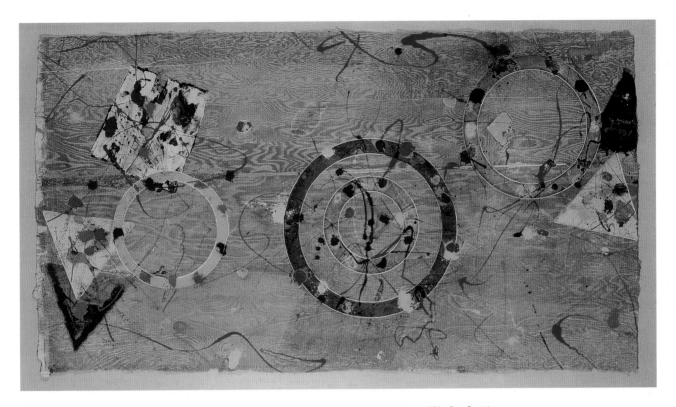

102. Sam Francis
American, b. 1923
Untitled, 1982
Woodcut monotype with oils and dry pigments
Sheet/image 43 x 78.5" (109 x 199.5)
Vote for Art Purchase

103. Scott Richter
American, b. 1943
Pope, 1989
Beeswax, wire, wood, pigment, and foam
26 x 22.5 x 9.5" (66 x 57 x 24)
Gift of the Friends of Contemporary Art

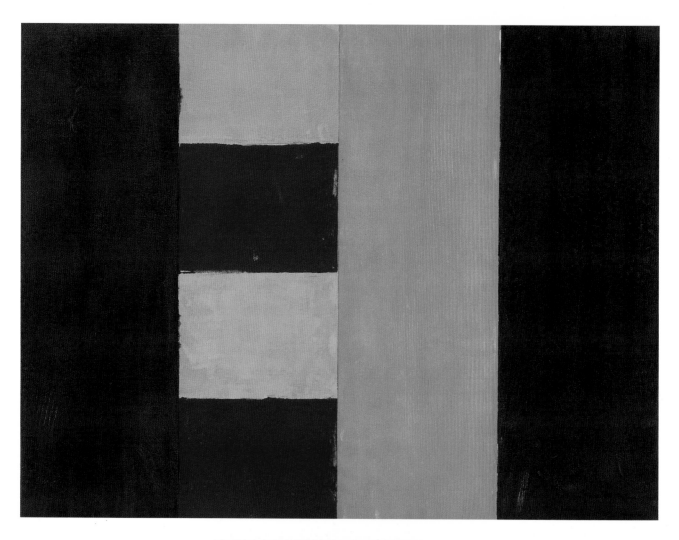

104. Sean Scully
Irish (active America), b. 1945
Santa Barbara Series #35, 1987
Monotype
41.5 x 55" (105.5 x 139)
Museum purchase with funds
provided by the
Charles and Mildred Bloom
Memorial Fund for the
Contemporary Graphics Center/
William Dole Fund Collection

105. John McLaughlin
American, 1898–1976
Number 5, 1961
Oil on canvas
42.5 x 60" (107.5 x 152.5)
Gift of Katherine Peake in memory
of her mother, Alice F. Schott

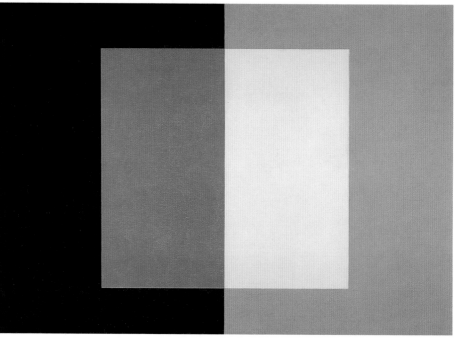

106. Ron Davis
American, b. 1937
Stalls, 1970
Polyester resin and fiberglass
68.5 x 116" (174 x 294.5)
Museum purchase with funds
provided by the National
Endowment for the Arts
and the Collectors' Group

107. Jud Fine
American, b. 1944
Dbl. OR, 1985
Oil stick, oil paint, acrylic,
graphite, ink, colored ink and
prisma stick on canvas;
bamboo, chicken wire and steel
80.5 x 156.5" (204.5 x 397);
column 96 x 12" diameter
(244 x 30.5)
Gift of Barry and Gail Berkus

108. Barbara Kasten
American, b. 1936
Construct XIX, ed. 4/6, 1982–83
Cibachrome print
Sheet 30 x 40" (76 x 101.5);
Image 29.5 x 37" (75 x 94)
Museum purchase,
The Rowe S. Giesen Memorial Fund

109. Bridget Riley
English, b. 1931
Annul, 1965
Emulsion on board
21.5 x 21.5" (54 x 54)
Museum purchase

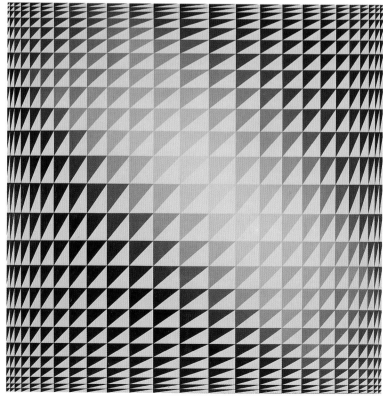

110. Al Held
American, b. 1921
Brughes II, 1981
Acrylic on canvas
84 x 84" (213.5 x 213.5)
Gift of Carol L. Valentine

Asian

THE ASIAN ART COLLECTION began with the Museum's inception in 1941, when Mrs. Philip Stewart donated nineteen woven and embroidered Chinese court robes, and Wright S. Ludington loaned and later donated ninety-two Oriental artworks from the Charles Henry Ludington collection. These outstanding religious sculptures, Chinese ceramics, paintings, and textiles, along with subsequent acquisitions made by Ina T. Campbell, K. W. Tremaine, and Wright S. Ludington in the forties and fifties, formed the nucleus of the Asian collection. Today, strengthened by gifts and occasional purchases, this excellent collection includes approximately 2200 objects in a variety of media. It spans a period of two thousand years and a wide range of Asian cultures—China, India, Japan, Korea, Tibet, and Southeast Asia—with works grouped into six major areas: religious sculptures, Chinese ceramics, paintings, Japanese woodblock prints, textiles and other decorative arts.

Inspired mostly by the Buddhist and Hindu faiths of India, Asia's large religious sculptures are of immense historical and artistic importance, and the Museum is extremely fortunate to have a number of excellent examples. The diversity apparent in the sculptures, in style, medium, and place of origin, illustrates the wide spread of the two religions on the Asian continent and the way in which the faiths were modified to conform to different cultural concepts and national aesthetics. The Indian concern for dynamic poses and sensuous bodily forms, seen in the eleventh-century sandstone *Balarma as the Avatar of Vishnu* [pl. 120] and thirteenth-century bronze *Dancing Krishna* [pl. 122] contrasts sharply with the twelfth-century Chinese *Standing Bodhisattva Guanyin* [pl. 118] in which the native predilection for linear rhythm is expressed in the graceful handling of the drapery.

In the sixties and seventies, collectors such as Prynce Hopkins and Lewis Bloom continued to donate important sculptures, such as the eighth-century Chi-

nese *Buddhist Stele, Amitabha Buddha and the Western Paradise* [pl. 115], and the thirteenth-century Indian *Chandesvara*. The Museum's selection of large religious sculptures now includes over twenty magnificent works from India, China, Japan, Thailand and Cambodia in wood, stone and bronze, almost all of which, together with a group of smaller Tibetan Buddhist works [pls. 123–125], are on permanent display in the Sterling Morton Gallery.

Another major strength of the Asian collection is a group of approximately fifty-five Chinese ceramics on display which illustrates the long history of the development of Chinese ceramics, and at the same time reflects the various stages of one of the world's most ancient and continuous civilizations.

The earliest group of ceramics includes superb examples of a variety of funerary sculptures and wares from the Han through the Tang periods (206 B.C.-906 A.D.). Most of these funerary objects are replicas of household items which were buried with the dead to provide for their comfort in the afterlife, a belief that evolved from earliest Neolithic times. Models of miniature well heads, animals, houses, zodiac figures [pl. 112], and replicas of containers such as the Han hill jar [pl. 111] and the Tang dynasty dragon-head-handled amphora jar [pl. 114] not only trace the technological advancement of the ceramic industry—from hand-made to wheel-thrown earthenware to high-fired stoneware—but also capture a cross-section of daily life in the Han and Tang societies.

Middle period ceramics are represented by a small but exquisite group of Song dynasty (960-1279) pieces. These famed porcelaneous stonewares of Ding plates, Qingbai bowls, and Northern celadons [pls. 129-130] with their elegant shapes and subtly decorated monochrome glazes of ivory, and pale shades of green and blue represent sophisticated and aristocratic tastes. In contrast, stonewares of the same period which were intended for the everyday use of the less privileged exhibit unusually exuberant decorative designs with

strong glazes of black and brown in boldly conceived shapes [pl. 128].

The Museum's later period ceramics, from after the fifteenth century, are few but growing with the generous help of collectors such as Walter G. Silva, Carroll and Suzanne Barrymore and F. Bailey Vanderhoef, Jr. In 1989, the Friends of Oriental Art, a Museum support group founded in 1974 to further interest and acquisitions in Asian art, raised funds to purchase the splendid eighteenth-century imperial Chinese porcelain Flying Crane Vase [pl. 132].

A small but excellent group of Chinese and Japanese paintings forms another important collection area. Painted hanging scrolls, handscrolls, and screens on paper and silk date primarily from the eighteenth and nineteenth centuries, with a few exceptions such as the superb fourteenth-century Chinese work *Lohan Holding an Altar Prayer Chorten* [pl. 126]. In China and Japan, painting, calligraphy, and poetry are considered the three highest forms of artistic expression, sharing common tools—brush and ink—and the long tradition of learning and history. The coexistence of these three sister arts is well illustrated in *Impressions of Mts. Jin and Jiao* by the famous eighteenth-century painter Gao Fenghan [pl. 131]. The expressive powers of the brush are masterfully displayed, from Wang Yü's controlled and orthodox *The Countenance of Hills and Rivers* [pl. 127] to the spontaneous but disciplined calligraphic strokes of Shiokawa Bunrin's *Assemblage of Folk Tale Characters: Otsu Picture Subjects* [pl. 133].

Of all Japanese arts, the woodblock print tradition of *ukiyo-e* ("pictures of the floating world") is probably the most widely known in the Western world. Admired for their distinct line, planar areas of color, and dynamically asymmetrical composition, these prints of courtesans, kabuki actors, and landscapes, have been collected by Westerners since the late nineteenth century. Therefore, it is no great surprise that Japanese woodblock prints are the most-represented area in the Museum's Asian collection, and now number more than nine hundred prints from the Edo (1603-1868) and Meiji (1868-1912) periods. Prints from the Edo period include works by such well-known artists as Koryusai, Eizan, Hokusai, and Hiroshige [pls. 134-135]. This selection was significantly enriched in recent years by the donation of two notable private collections of Meiji prints: a group of 220 works by Kobayashi Kiyochika [pl. 136], one of the largest collections outside of Japan, and a set of *One Hundred Aspects of the Moon* by Tsukiyoka Yoshitoshi. Kiyochika and Yoshitoshi are considered two of the greatest Meiji print designers, and the diverse aesthetics and highly innovative expressions of their work represent the last phase of the *ukiyo-e* tradition at the end of the nineteenth century as Japan underwent rapid changes in face of modernization.

Textiles and costumes represent one of the Museum's fastest growing areas of Asian art in recent years. Since the first gift of Chinese robes in 1941, the textile collection has expanded entirely through donations and now consists of approximately 550 works. Contributing immensely to the Museum's holdings are over two hundred Qing dynasty (1644-1911) court costumes, textiles, and hangings given by Ralph E. and Mary V. Hays [pl. 137], and the Paula and Ira Glick Fukusa Collection of fifty ceremonial gift covers which represents one of the largest concentrations of late nineteenth- to early twentieth-century *fukusa* outside Japan [pl. 138]. Other textiles of importance include Japanese *kesa* (Buddhist robes), a sizeable group of Japanese paper stencils used in resist-dyeing, and Filipino costumes and beadwork.

While not numerous enough to be thought of as individual collection areas, splendid examples of Chinese lacquers, jades, ivories, and snuff bottles, and Japanese *netsuke* (toggles), *inro* boxes, and bronzes complete the Museum's Asian art collection. The utilitarian origin of many of these objects attests not only to the ingenuity and craftsmanship of the Asian artisans but also to the long Asian tradition of a leisure class whose cultivated taste and patronage undoubtedly guided aesthetic standards in the arts.

111. China
Han Dynasty (206 B.C. – 220 A.D.)
Hill Jar
Reddish earthenware with olive green glaze
9 x 7.5″ (23 x 19)
Gift of Wright S. Ludington

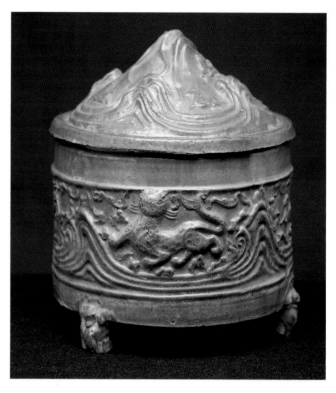

112. China
Six Dynasties, N. Wei period, ca. 6th century
Zodiac Figures
Earthenware, set of 12
ca. 9 x 4″ ea. (48.5 x 10)
Gift of Joseph Halle Schaffner

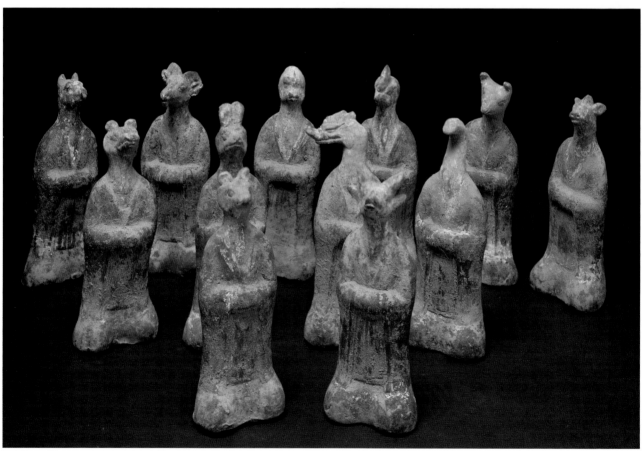

113. China
Sui Dynasty (581–618 A.D.)
*Mirror Back with Four Directional Creatures
and Twelve Zodiac Animals*
Bronze
10 x 0.5″ (25 x 1)
Gift of Wright S. Ludington
in memory of Charles Henry Ludington

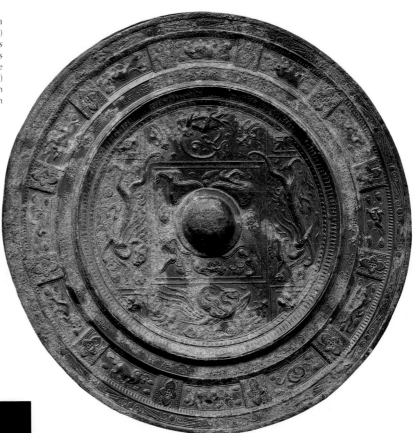

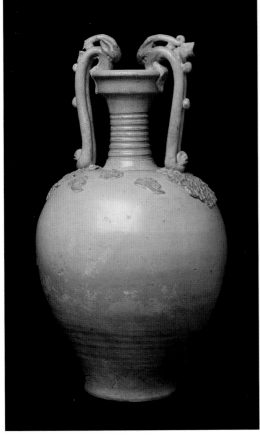

114. China
Tang Dynasty (618–906 A.D.)
Amphora with Dragon-Head Handles
Buff-white stoneware with pale green translucent glaze
16 x 9″ (40 x 23)
Gift of Wright S. Ludington
in memory of Charles Henry Ludington

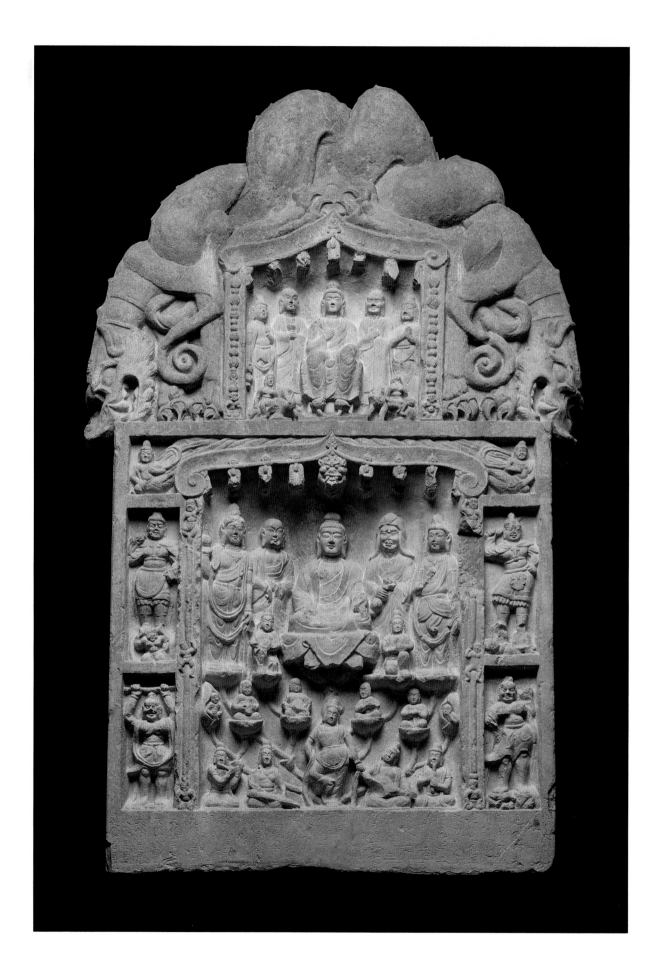

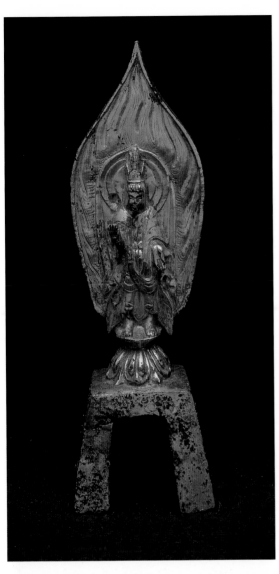

116. China
Six Dynasties, N. Wei Period (386-535 A.D.)
Standing Bodhisattva
Gilt bronze
7.5 x 2.5 x 2" (18.5 x 6 x 5)
Gift of Wright S. Ludington
in memory of Charles Henry Ludington

115. China
Tang Dynasty, 697 A.D.
*Buddhist Stele, Amitabha Buddha
and the Western Paradise*
Limestone
50 x 32 x 8.5" (127 x 81.5 x 21.5)
Bequest of Prynce Hopkins

117. Japan
*Greater Sutra of the Perfection
of Wisdom, Chapter 270,* 1383
Printed book, ink on paper with silver border
and guidelines
10.5 x 4 x 0.5" (26 x 9.5 x 1.5) detail
Gift of Philip Hofer

118. China
Jin Dynasty (1115–1234)
Standing Bodhisattva Guanyin
Polychromed wood
64.5 x 18 x 15" (164 x 45 x 38)
Gift of Wright S. Ludington

119. China
Yuan Dynasty (1279–1368)
Seated Lohan
Wood, dry lacquer, polychromed gesso
45.5 x 27" (115.5 x 68.5)
Gift of Ina T. Campbell

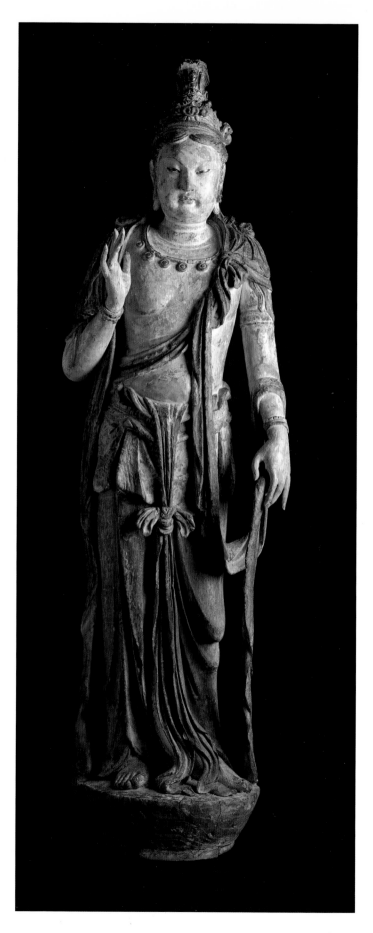

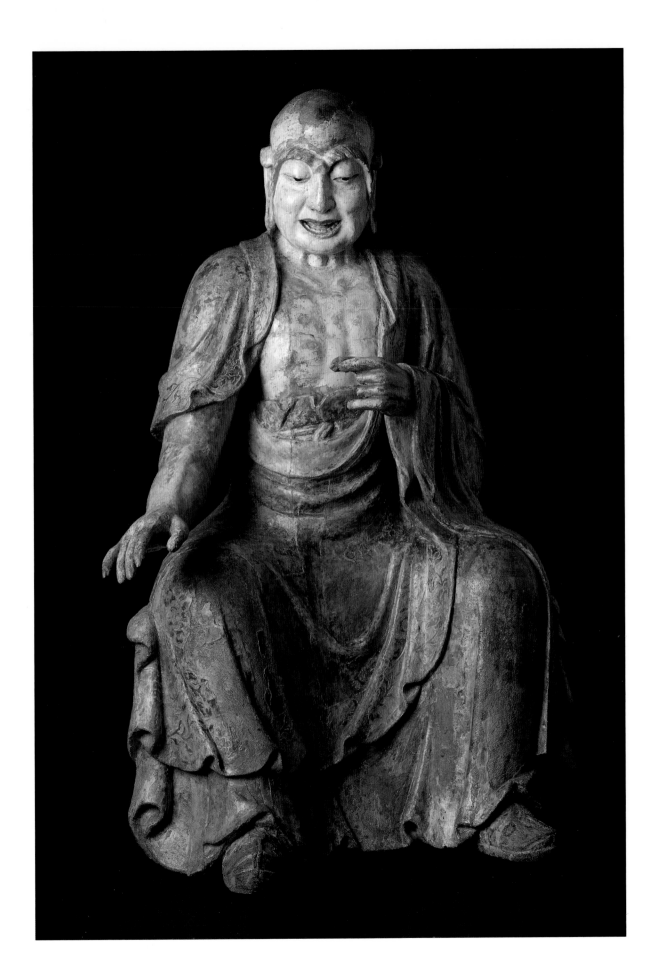

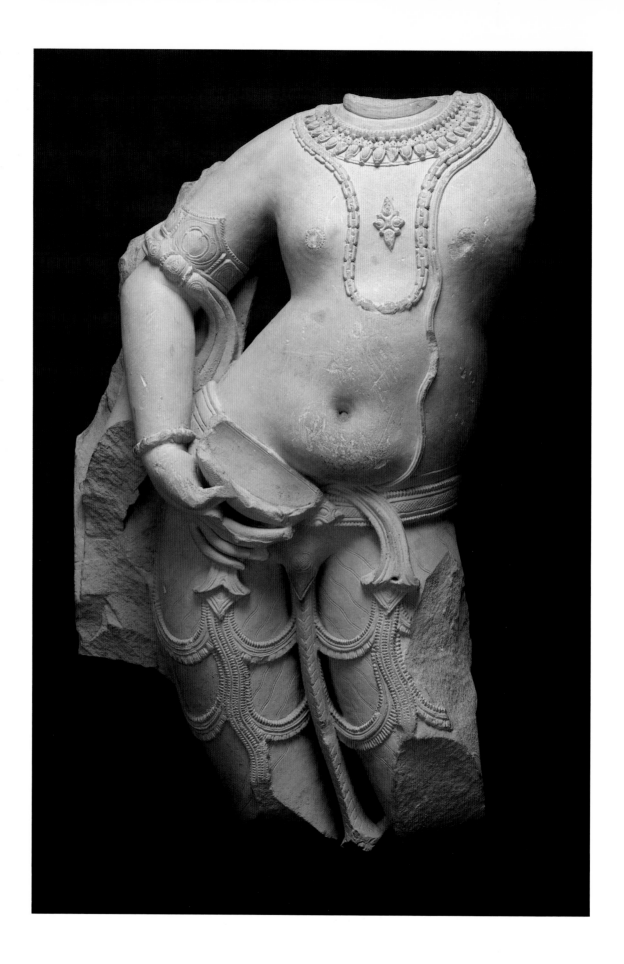

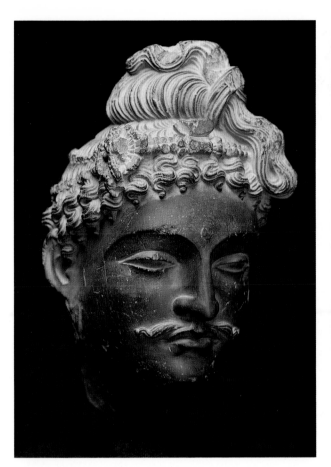

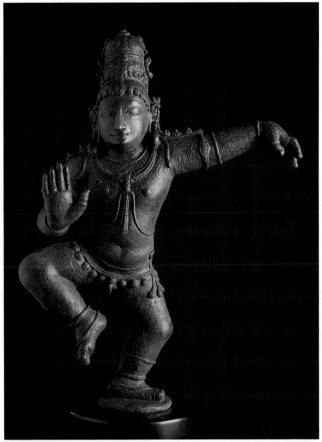

121. Gandhara India
2nd–4th c. A.D.
Head of a Bodhisattva
Grey schist
12 x 7 x 5" (30.5 x 17 x 13)
Gift of Wright S. Ludington

122. South India
Late Chola period, 13th c.
Dancing Krishna
Bronze
18.5 x 13 x 5.5" (47 x 33 x 14)
Museum purchase

120. India
11th c.
Balarama as the Avatar of Vishnu
Buff sandstone
31 x 20" (78.5 x 50.8)
Gift of K. W. Tremaine

123. Tibet, 18th c.
Second Panchen Lama, Bho-bzang Ye Shes
(1663–1737)
Gilt bronze
6 x 4 x 3.5″ (15.5 x 10 x 8.5)
Bequest of Ina T. Campbell

124. Tibet, 19th c.
Magic Dagger
Brass and silver
ca. 6.5″ (16.5)
Gift of Mrs. Wilbur L. Cummings, Sr.,
in memory of her son,
Wilbur L. Cummings, Jr.

125. Unknown artist
Tibetan, 16th–17th century
Mandala of a Goddess
Gouache on cotton
20 x 18″ (51 x 46)
Gift of Clare Harrison

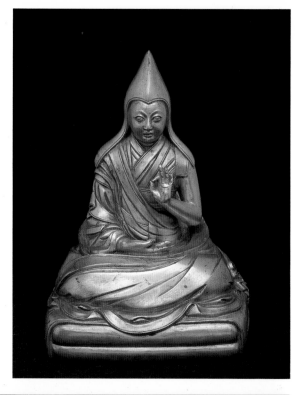

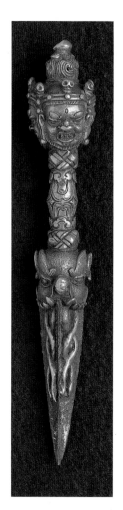

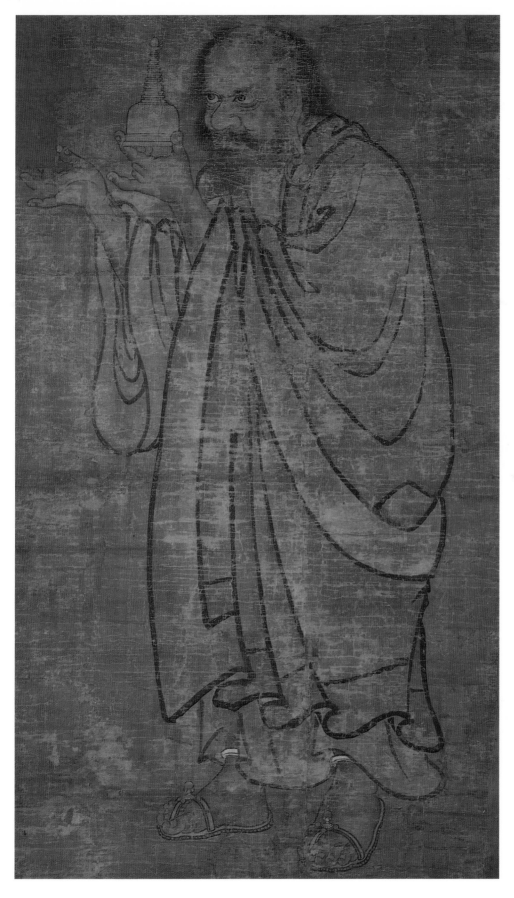

126. Unknown artist
Chinese, Yuan Dynasty (1279–1368)
Lohan Holding an Altar Prayer Chorten
Ink and colors on silk
64 x 37″ (162.5 x 94)
Gift of Wright S. Ludington in
memory of Charles Henry Ludington

Asian 99

127. Wang Yü
Chinese, ca. 1680–1750
The Countenance of Hills and Rivers, 1729
Ink and color on paper, hanging scroll
61 x 34″ (154.5 x 86.5)
Museum purchase with funds provided
by gifts from Frederick B. Kellam,
Mrs. Lockwood de Forest, O.S. Southworth,
Mrs. Sidebotham & Mrs. Robert Woods Bliss

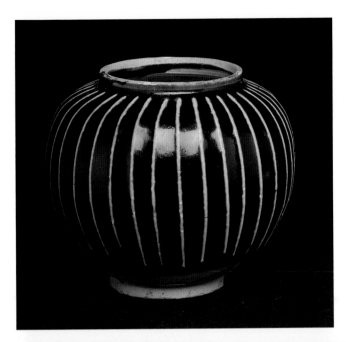

128. China
Song Dynasty (960–1279)
Jar
Cizhou type ware, grey stoneware with cream-white slip under a thick black glaze, ribbed design
h 4.5″ (11)
Museum purchase with funds provided by Friends of Oriental Art and from gifts of Mrs. Burwell B. Smith and Carroll and Susanne Barrymore

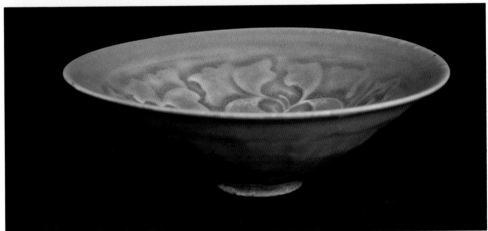

129. China
Northern Song Dynasty (960–1127)
Conical Bowl
Northern celadon, porcelaneous stoneware with olive green glaze over impressed peony design
2 x 6″ dia. (5 x 15 dia.)
Gift of Wright S. Ludington in memory of Charles Henry Ludington

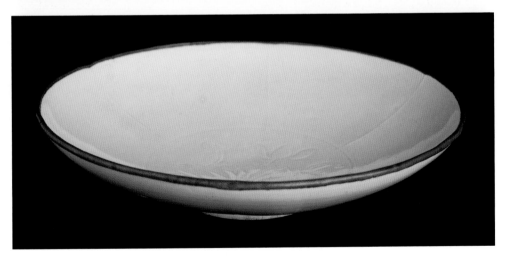

130. China
Northern Song Dynasty (960–1127)
Six-Lobed Dish
Ding ware, porcelaneous stoneware with incised lotus designs under ivory-white glaze, copper rim
2 x 7″ dia. (4.5 x 18 dia.)
Gift of Wright S. Ludington in memory of Charles Henry Ludington

Asian 101

131. Gao Fenghan
Chinese, 1683–1749
Impressions of Mts. Jin and Jiao, 1745
Ink on paper, hanging scroll
58 x 22.5" (146.5 x 57)
Museum purchase with funds provided
by Marguerite Putnam Keyes

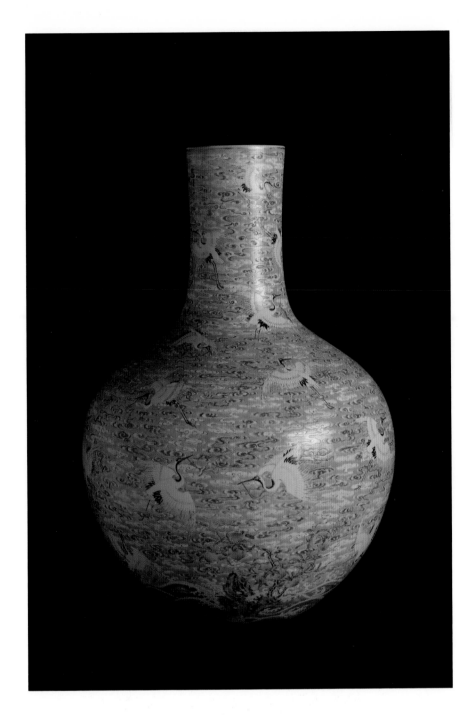

132. China
Qing Dynasty, Qianlong period (1735–1795)
Vase
Porcelain painted with overglaze
polychrome enamels
21.5 x 14.5" (54.5 x37)
Museum purchase with funds provided
by Friends of Oriental Art

133. Shiokawa Bunrin
Japanese, ca. 1808–1877
*Assemblage of Folk Tale Characters:
Otsu Picture Subjects,* 1871
Ink and light color on silk
65 x 36.5" (165 x 93)
Museum purchase with funds
provided by Friends of Oriental Art

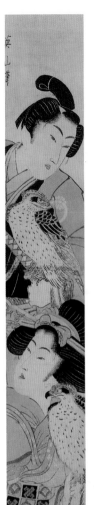

134. Kikugawa Eizan
Japanese, 1787–1867
Falconers
Pillar print, colored woodblock print on paper
24.5 x 4" (61.5 x 10.5)
Gift of Mrs. Edward R. Valentine

135. Katsushika Hokusai
Japanese, 1760–1849
Waterwheel at Onden,
from series *Thirty-Six Views of Mount Fuji*
Colored woodblock print on paper
9.5 x 14.5" (24.5 x 36)
The Frederick B. Kellam Collection

136. Kobayashi Kiyochika
Japanese, 1847–1915
*Taira no Tadamori Captures the Priest
of Mido Temple*, ca. 1883–84
Triptych, colored woodblock print on paper
12.5 x 26.5" (32 x 17)
Gift of Mr. and Mrs. Roland A. Way

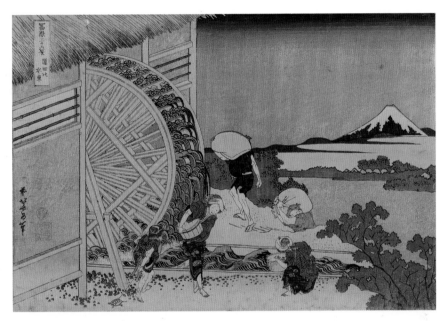

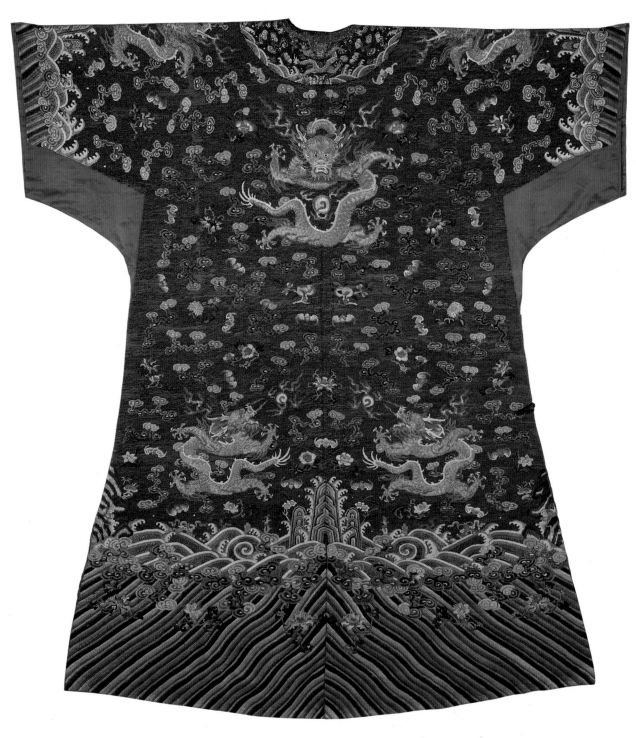

137. China
Qing Dynasty, ca. 1790–1825
Imperial Semi-formal Court Coat
Silk; peacock feather and gold couching
56.5 x 74.5" (143 x 189)
Gift of Ralph E. and Mary V. Hays

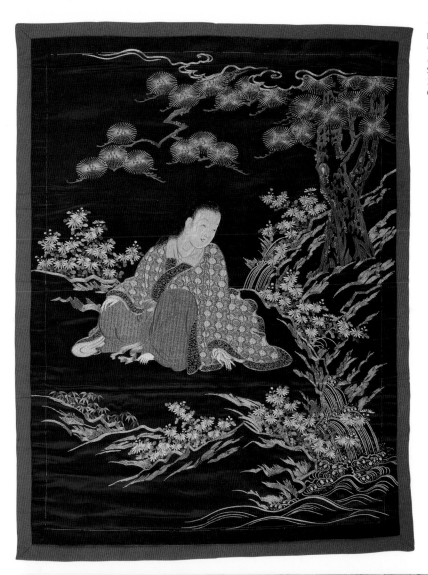

138. Japan
Edo period, late 18th c.
Gift Cover (Fukusa) with Figure
Beside a Rushing Stream
Satin; silk and gold embroidery
36 x 27.5" (99 x 70)
Gift of Paula and Ira Glick Fukusa Collection

139. China
Qing Dynasty, 17th c.
Altar Frontal
Silk, gilt and silver wrapped threads;
kesi (tapestry weave)
37 x 69" (94 x 175.5)
Gift of Mrs. Philip B. Stewart

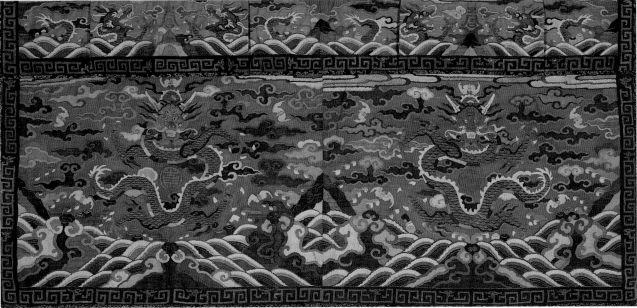

Asian 107

Bibliography

CATALOGUES OF THE
PERMANENT COLLECTION
PUBLISHED BY THE
SANTA BARBARA MUSEUM OF ART

The Ala Story Collection of the Santa Barbara Museum of Art; Exhibited on the Occasion of the Museum's Thirtieth Anniversary, June 6, 1971. 1971.

[Bloch, E. Maurice.] *Two Hundred Years of American Painting.* 1961.

Burns, Roger C., et al. *Archivero I; Research Papers on Works of Art in the Collection of the Santa Barbara Museum of Art.* 1973.

Del Chiaro, Mario A., with an additional contribution by Andrew F. Stewart. *Classical Art: Sculpture.* 1984.

_____. *The Collection of Greek and Roman Antiquities at the Santa Barbara Museum of Art.* 1962.

Dorra, Henri. "The McCormick Bequest." *Santa Barbara Museum of Art Bulletin I,* no. 1. 1970.

Farwell, Beatrice. *The Charged Image: French Lithographic Caricature 1816-1848.* 1989.

French Art of the Nineteenth and Early Twentieth Centuries. [1988.]

[Henning, Robert.] *Wright S. Ludington; Four Decades of Gifts to the Santa Barbara Museum of Art.* 1982.

The Holy Family; Painting by Pieter de Witte. 1962.

[Kuchta, Ronald.] *Drawings; The Collection of the Santa Barbara Museum of Art.* 1970. 2d ed., 1971. 3d ed., 1973.

McKenzie, A. Dean. *Russian Icons in the Santa Barbara Museum of Art.* 1982.

Mead, Katherine Harper, ed. *The Preston Morton Collection of American Art.* 1981.

Moir, Alfred, ed. *European Drawings in the Collection of the Santa Barbara Museum of Art.* 1976.

Osman, Randolph E. *Iconocom; Cross-Cultural Iconography for the Community.* 1973.

[Ross, Richard.] *101 Photographs; Selections from the Arthur and Yolanda Steinman Collection.* 1984.

[Seldis, Henry J.] *Donald Bear Memorial Collection.* 1964.

Smith, Henry D., II. *Kiyochika: Artist of Meiji Japan.* 1988.

Spurlock, William, ed. *Santa Barbara Museum of Art Contemporary Graphics Center/William Dole Fund Collection.* 1980.

[Story, Ala.] *The Ala Story Collection of the Santa Barbara Museum of Art.* 1967.

Wallen, Burr. *The William A. Gumberts Collection of Canaletto Etchings.* 1979. Reprint, 1987.

[West, Richard V.] *The Ala Story Collection of International Modern Art.* 1984.

West, Richard V. *In Tribute to William Dole.* 1983.

[West, Richard V., et al.] *From Avery to Zurbaran; A New View of the Permanent Collection.* 1983.